MW01256235

Barbara Nitke
Kiss of Fire

All records required by 18 U.S.C.
Section 2257 are in the custody of
Barbara Nitke, 300 East 34 Street
#6B, New York, NY 10016. Date
of production: October 3, 1998

Foreword

by Barbara Nitke

In the fall of 1994, I began to photograph lovers in the SM scene in New York. My work had explored issues of sexual desire for many years, and sadomasochism was not new to me. It was the natural next step in my journey.

Earlier in my career, I worked as a set photographer on over three hundred hardcore and SM/fetish porn movies. This gave me a great vantage point behind the scenes, and my personal work from those years reveals the human beings behind the sex machine image. The moments I loved most were when they called a cut in the middle of an orgy scene, and the actors would drop their guard. They'd pull out a cigarette and stare off into space, like combat soldiers with a thousand yard stare. Except that they were naked, surrounded by the accouterments of the sex business.

For years, those were the little ironic moments I loved to shoot. When I began photographing lovers in the leather community, my vision changed. Suddenly, it was in the sexual moment – or the moment deep in SM play – when I thought the people were most profoundly real. And that became the truth I wanted to record.

I attended my first meeting of The Eulenspiegel Society in order to see a presentation by Charles Gatewood. I consider him a master photographer of the underground, and had admired his work for years.

I was escorted by a famous porn star, Rick Savage, and his girlfriend Allyn, a long time Eulenspiegel member. We were met at the door by an imposing black woman with short cropped, shocking blond hair – Morgan Lewis HMQ. She looked at me and said in a booming voice, »Oh, I'm so glad you could come!« In that instant I knew an amazing door had just opened for me.

The Eulenspiegel Society (or TES) is the oldest and largest SM support and educational group in the country, with close to a thousand members. They hold meetings every Tuesday and Wednesday night, as well as weekend workshops and parties. For the most part their membership consists of middle class people – nurses, lawyers, computer experts, corporate managers – ranging in age from 21 to 80.

Vorwort

von Barbara Nitke

Im Herbst 1994 begann ich Liebespaare aus der SM-Szene von New York zu fotografieren. Seit Jahren bereits ging es in meiner Arbeit um die unterschiedlichen Facetten der sexuellen Begierde, so dass mir auch Sadomasochismus nicht fremd war. Er bildete den natürlichen nächsten Schritt auf meiner Reise.

Früher in meiner Laufbahn habe ich als Set-Fotografin für mehr als dreihundert Hardcore- und SM/Fetisch-Pornofilmproduktionen gearbeitet, was der denkbar beste Ausgangspunkt für einen Blick »hinter die Kulissen« war. Mein persönliches Werk aus diesen Jahren zeigt den Menschen, der hinter der Sexmaschine steht. Am liebsten waren mir die Augenblicke, wenn mitten in einer Orgienszene »Schnitt« gerufen wurde und die Akteure ihre Maske fallen ließen. Sie zündeten sich eine Zigarette an und starrten gedankenverloren ins Leere wie Soldaten nach der Schlacht. Nur dass sie nackt waren, umgeben von den Requisiten des Sex-Business.

Jahrelang waren es gerade diese kleinen ironischen Momente, die mich beim Fotografieren am meisten faszinierten.

Als ich dann in der Lederszene zu fotografieren begann, änderte sich mein Blickwinkel. Plötzlich schien es mir gerade der sexuelle Augenblick zu sein – oder der Augenblick tiefer Versunkenheit in das SM-Spiel –, bei dem die Menschen ganz zu sich selbst kamen. Und das wurde die Wahrheit, die ich festhalten wollte.

Um eine Ausstellung von Charles Gatewood zu sehen, nahm ich erstmals an einem Meeting der Eulenspiegel Society teil. Ich halte Gatewood für einen Meisterfotografen des Underground und bewundere ihn schon seit Jahren. Begleitet wurde ich von dem bekannten Pornostar Rick Savage und seiner Freundin Allyn, die schon seit langem Eulenspiegel-Mitglied war. Am Eingang begrüßte uns eine imponierende Schwarze mit kurzgeschorenem schockblondem Haar – Morgan Lewis HMQ (»Her Majesty the Queen«). Sie blickte mich an und sagte mit dröhnender Stimme: »Oh, ich freue mich so, dass Sie kommen konnten!« In diesem Moment wusste ich, dass sich mir eine Tür mit phantastischen Möglichkeiten geöffnet hatte.

The Eulenspiegel Society (TES) ist Amerikas größte und älteste Organisation, die die Interessen der SM-Szene in der Öffentlich-

For many months I attended meetings without ever bringing a camera. I knew I wanted to take pictures, but I couldn't define what it was that so fascinated me.

HMQ greeted me warmly whenever she was there, and Allyn introduced me to a lot of people. They thought it was kind of cool that I had worked on so many X-rated movies, and that I had a sense of humor about how lame they were, especially the fetish ones.

I saw demonstrations on the sensual use of hot wax, bondage techniques, spanking scenes, role playing, whipping, caning, corsetry, Master/slave relationships. The spectrum of activities that people discussed and taught was staggering.

They debated endlessly about the proper use of safewords – the word that the bottom uses when he or she wants the scene to stop. They spent whole evenings talking about how to negotiate safe, mutually satisfying scenes, and on how to define and respect each other's limits. They talked about the difference between real life SM, and fantasies like *The Story of O,* and how to safely reenact them. I was riveted one night by Lady Green's description of how to create for a bottom the sensation of being skinned alive, without ever puncturing the skin.

Friday and Saturday nights I went out to Hellfire, Paddles, and the Vault. These were SM clubs where people went to play in each other's company, or to mill around hoping to meet someone. I also attended private parties for TES members, where all the best players would turn out, and the best scenes would happen.

People in the public leather scene like to play with others watching. They are different from the people who engage in SM and fetish activities in the privacy of their bedrooms. Public players like the group energy. They like to feel members of the tribe around them, feeding their scene with energy. What they don't like around them are the tourists, or lookey-loos, who come out to watch the freaks.

As people in the scene gradually accepted me and welcomed me to their parties and clubs, I felt privileged. I got teased a lot, but I was given what I considered an honored position as voyeur in the group. When a foot fetishist at Hellfire accused me of exploiting the scene by photographing everybody when I wasn't part of it, Lolita Wolf jumped up and said I was as much a member of the community as anybody else. That meant the world to me.

keit vertritt. Sie zählt an die 1000 Mitglieder. Jeden Dienstag- und Mittwochabend finden Treffen statt, daneben an den Wochenenden Workshops und Partys. Die Mitglieder stammen meist aus der Mittelschicht – Krankenschwestern, Rechtsanwälte, Computerexperten, Manager – und sind zwischen 21 und 80 Jahre alt.

Viele Monate ging ich erst einmal ohne Kamera zu den Treffen. Ich wusste, dass ich Bilder machen wollte, konnte aber zunächst nicht genau sagen, was mich so faszinierte. HMQ begrüßte mich herzlich, wenn sie da war, und Allyn stellte mich vielen Leuten vor. Alle fanden es cool, dass ich für so viele Erotikfilme gearbeitet hatte und dass ich darüber spotten konnte, wie lahm sie waren, besonders die Fetisch-Filme.

Ich sah Vorführungen über den sinnlichen Gebrauch von heißem Wachs, Bondage-Techniken, Spanking-Szenen, Rollenspiele, Auspeitschen, Rohrstock, Korsett, Master/slave-Beziehungen. Das Spektrum der Aktivitäten, die man hier besprach und lehrte, war wirklich überwältigend.

Endlos wurde zum Beispiel über den richtigen Gebrauch von Safewords diskutiert – die Worte für den Bottom, wenn er bzw. sie die Szene stoppen will. Ganze Abende verbrachten sie mit Debatten, wie man ungefährliche, beidseits befriedigende Szenen abspricht und wie man die gegenseitigen Grenzen definiert und respektiert. Man sprach über den Unterschied zwischen wirklichem SM und Fantasien wie *Die Geschichte der O* und wie man sie gefahrlos nachspielen kann. Gebannt lauschte ich eines Abends Lady Green, die erzählte, wie man für einen Bottom das Gefühl schafft, bei lebendigem Leibe gehäutet zu werden, ohne dass die Haut auch nur angeritzt wird.

An Freitag- und Samstagabenden besuchte ich die SM-Clubs Hellfire, Paddles und Vault. Man kam hierher, um in guter Gesellschaft zu spielen, oder als Zaungast, in der Hoffnung, jemanden kennen zu lernen. Ich besuchte auch Privatpartys für TES-Mitglieder, wo die aktivsten Spieler und die besten Szenen zu erwarten waren.

Die Leute in der »öffentlichen« Lederszene spielen gern vor Zuschauern. Sie unterscheiden sich von denen, die SM- und Fetisch-Spiele lediglich für sich im Schlafzimmer vollziehen. Die öffentlich agierenden Spieler brauchen die Gruppenenergie. Sie lieben das Gefühl, die Gesinnungsgenossen um sich zu haben und daraus Energie

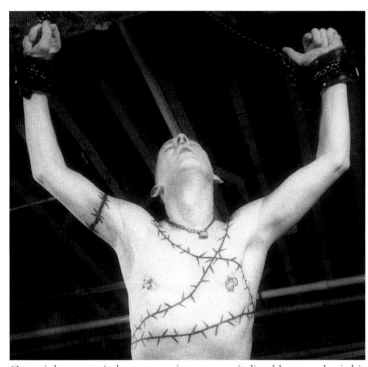

One night wynn (whose name is never capitalized because he is his husband Gary's slave) told me what it felt like when he pierced himself with hypodermic needles. It was a beautiful summer night, and we were up on the roof of the Vault, with bondage and whipping scenes happening all around us. I remember being mesmerized by the setting and the night, and wynn's breath-taking description. He said that the pain from the needles produced endorphins that raced through his body, and then detached so that his spirit left and went out and above flying through the world at the speed of light, seeing colors upon colors, marvelous and beautiful beyond words. Out of his body, he flew, flew, flew. I listened to him fascinated, and then said, »But how could I show that on film?«

The next morning I woke up with the answer, black-and-white infrared film. That film is normally used for unusual effects in landscape photography. But with people, it produces an ethereal effect. The skin becomes whiter than normal, and even glows. There's a high level of grain, which I felt would enhance the romantic effect I was looking for.

Eventually I realized that while the mechanics of sadomasochism and the other various activities and rituals were interesting, they

für ihre Szene zu ziehen. Was sie nicht brauchen, sind »Touristen« oder Gaffer, die kommen, um sich die »Perversen« anzuschauen.

Als man mich in der Szene allmählich akzeptierte und auf den Partys und in den Clubs willkommen hieß, fühlte ich mich richtig geehrt. Man trieb zwar seine Scherze mit mir, gestand mir aber offensichtlich eine Art Ehrenrolle als Voyeur zu. Als mir ein Fußfetischist im Hellfire einmal vorwarf, ich würde die Szene ausnutzen, indem ich als Nichtteilnehmer jedermann fotografierte, sprang Lolita Wolf auf und rief, ich sei genauso Mitglied der Gruppe wie alle anderen. Das bedeutete mir außerordentlich viel.

Eines Abends erzählte mir wynn (dessen Name stets kleingeschrieben wird, weil er der Sklave seines Ehemanns Gary ist), welches Gefühl es für ihn war, sich mit Braunülen zu piercen. Es war ein herrlicher Sommerabend, wir waren alle oben auf dem Dach des Vault, um uns überall Bondage- und Flag-Szenen. Ich entsinne mich, dass ich wie hypnotisiert war von dieser Kulisse und dem Abend und wynns atemberaubender Schilderung. Er sagte, der Schmerz der Nadeln habe Endorphine durch seinen Körper rasen lassen, so dass sein Geist sich losgelöst habe und fortgeflogen sei, mit Lichtgeschwindigkeit durch die Welt, dass er einen Rausch an Farben gesehen habe, zauberhaft und unbeschreiblich schön. Er sei herausgeflogen aus seinem Körper, und geflogen, und geflogen, und geflogen. Ich hörte ihm fasziniert zu und sagte dann: »Aber wie könnte ich das auf Film zeigen?«

Am nächsten Morgen, beim Aufwachen, hatte ich die Lösung: schwarz-weißer Infrarotfilm. Er wird normalerweise für bestimmte Effekte in der Landschaftsfotografie verwendet. Menschen lässt er ätherisch aussehen, ihre Haut wird weißer als gewöhnlich, so dass sie förmlich leuchtet. Der Film ist relativ körnig, was ich zur Steigerung der romantischen Wirkung einsetzen wollte.

Schließlich erkannte ich, dass die technischen Details des Sadomasochismus und der anderen Aktivitäten und Rituale zwar interessant, für mich aber letztlich Nebensache waren. Es zog mich zu den Liebenden. Immer wieder sah ich sie ja, auf den Partys, getragen auf den Flügeln ihrer Endorphine, ineinander aufgehend. Ich liebte, wie sie die Tage damit zubrachten, komplizierte und köstliche Szenen auszutüfteln und dann hinterher wie spitzbübische Kinder darüber zu sprechen. Immer funkelten Leonard Dworkins Augen, wenn er

were not my particular focus. I was drawn to the lovers. I couldn't help watching them together at parties, flying on their endorphins, lost in each other. I loved the ones who would spend days cooking up intricate, delicious scenes to tantalize the other, and then talk about it afterwards like mischievous kids. Leonard Dworkin's eyes sparkled whenever he told me about the scenes he concocted for his »little girl« Michele, a Ph. D. candidate in her thirties.

I realized I wanted to photograph their delight in each other, mixed with the dark intensity and passion of sadomasochism. I wanted to capture the deep trust that leather couples share.

I finally worked up the courage to ask some of the couples if they would allow me to photograph them. Gradually, they began to agree. Usually the people who allowed me to photograph them were people I had already watched quite a bit. They were used to seeing me at parties and clubs, and they often said they enjoyed my watching them.

The shoots we did were collaborations. We would talk beforehand about where to do the shoot, what to wear, what type of scene to do. One of my favorite locations was Hellfire, where the owner, Lenny, would let us shoot on Saturday afternoons before they opened for business. That place always felt like home to me, because I knew every corner. But I also shot in hotels and interesting looking odd places, and of course people's homes.

After the first few shoots, I understood that what I was shooting was a threesome, with me as the third. (Or fourth, as the case may be.) I wasn't a fly on the wall or a neutral observer. The people were allowing me into their lovemaking, much like at the clubs or parties where the presence of others intensifies the scene. The shoots weren't a direct turn on for me, but there was an undeniable charge. Susan Wright, a well-known SM activist, once made the observation that my scene was taking the photos. I believe that's true. I was often as high as everybody else when we were finished.

For some people, deciding to be photographed was a difficult decision. I always made it clear that I wanted their faces to be seen and that I eventually wanted to use the pictures in mainstream art galleries and hopefully a book. There were many people who wanted to be a part of the project, but couldn't because they knew that a connection with SM could mean losing their job. For people with

mir Szenen schilderte, die er für sein »kleines Mädchen« Michele ausgedacht hatte, eine Doktorandin in den Dreißigern.

Ich erkannte, dass ich ihr Ineinander-Schwelgen fotografieren wollte, zusammen mit der dunklen Intensität und Leidenschaft des Sadomasochismus. Ich wollte das tiefe Vertrauen einfangen, das unter Lederpaaren herrscht.

Irgendwann fasste ich mir ein Herz und fragte einige Paare, ob sie sich von mir fotografieren lassen wollten. Langsam kamen die ersten Zusagen. Es handelte sich dabei meist um Paare, die ich schon länger kannte und beobachtet hatte. Sie waren daran gewöhnt, mich auf Partys und in Clubs zu sehen, und sagten oft, sie hätten es gern, wenn ich zuschaute.

Unsere Fotosessions waren immer Kooperationen. Zunächst sprachen wir ab, wo wir die Sitzung abhalten, was getragen werden, welche Art Szene gespielt werden sollte. Zu meinen Lieblingslocations zählte das Hellfire. Der Besitzer Lenny ließ uns dort an Samstagnachmittagen fotografieren, wenn der Club noch geschlossen war. Ich fühlte mich dort immer wie zu Hause, weil ich jede Ecke kannte. Aber wir fotografierten auch in Hotels und an interessant aussehenden x-beliebigen Orten und natürlich auch in Privatwohnungen.

Gleich nach den ersten Session begriff ich dann, dass ich eigentlich einen Dreier fotografierte – mit mir als drittem Partner. (Oder dem vierten, je nachdem.) Ich war keine Fliege an der Wand, kein neutraler Beobachter. Die Akteure bezogen mich ein in ihr Liebesspiel, ganz ähnlich wie in den Clubs und auf den Partys, wo die Anwesenheit anderer die Szene intensiviert. Direkt angetörnt haben mich die Sitzungen nicht, aber anregend war's schon. Susan Wright, eine bekannte SM-Aktivistin, bemerkte einmal, meine »Szene« bestehe eben darin, die Bilder zu schießen. Ich glaube, sie hatte Recht. Hinterher war ich oft ebenso high wie alle anderen auch.

Für manche war es eine schwierige Entscheidung, sich fotografieren zu lassen. Ich habe immer darauf bestanden, dass ihre Gesichter sichtbar sein sollten und dass ich die Bilder irgendwann in normalen Kunstgalerien ausstellen und vielleicht sogar zu einem Buch verarbeiten wollte. Viele hätten gern mitgemacht, konnten aber nicht, weil sie wussten, dass ein Outing als SM-Teilnehmer sie den Job kosten konnte. Für Leute mit Kindern bestand die zusätzliche Gefahr,

children, there was the extra threat of having their kids taken away by social services professionals, just for having an SM sexual orientation.

I know that some of the people in this book are running a risk, and I believe they have chosen to do this only partly because they like my work. It's also because they are tired of being asked to feel ashamed of who they are sexually. Being openly depicted in scene with their lovers is a way of saying, »No more!«

The people I have photographed have given me an extraordinary gift. They have allowed me to be a part of their world in a way that I could have never conceived. Every single couple I've photographed throughout these years has taught me something new – about the nature of the erotic impulse, about sexual desire, about humanity. And above all, they have taught me that no matter how we're wired to express love, true freedom is in having the courage to be who we are.

dass das Jugendamt ihnen die Kinder wegnahm, nur wegen ihrer SM-Orientierung.

Ich weiß, dass manche Menschen in diesem Buch ein Risiko eingehen, und ich glaube, sie haben sich nicht nur dazu entschlossen, weil ihnen meine Arbeit gefällt. Sie sind es satt, dass von ihnen verlangt wird, sich ihrer sexuellen Identität zu schämen. Dass sie sich hier in einer Szene mit ihren Partnern abbilden lassen, ist eine Art öffentliches Bekenntnis: »Keine Heimlichkeit mehr!«

Die Menschen auf meinen Fotos haben mir ein außerordentliches Geschenk gemacht. Sie haben mich auf eine Art und Weise teilhaben lassen an ihrer Welt, die ich mir nie erträumt hätte. Jedes Paar, das ich in diesen Jahren fotografiert habe, hat mich irgendetwas Neues gelehrt – über die Natur des erotischen Impulses, über sexuelle Begierde, über Menschlichkeit. Und vor allem haben sie mich gelehrt: Egal, wie wir in der Liebe gepolt sind – wahre Freiheit heißt: Den Mut haben, zu sein, wer wir sind.

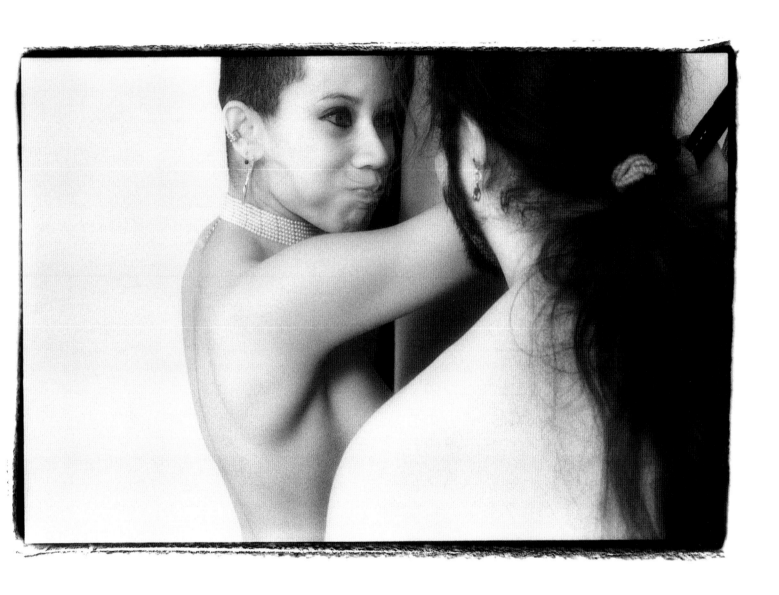

Mark and Velma

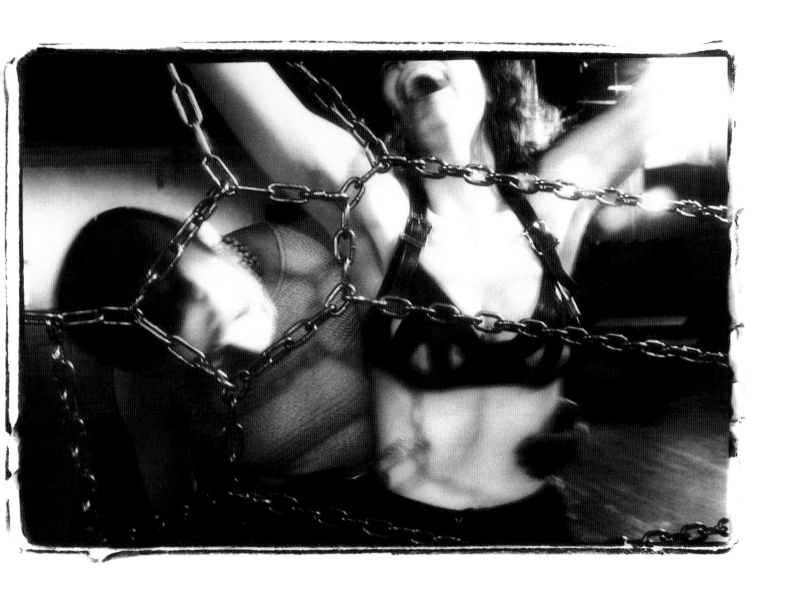

Velma and Elissa, I

21

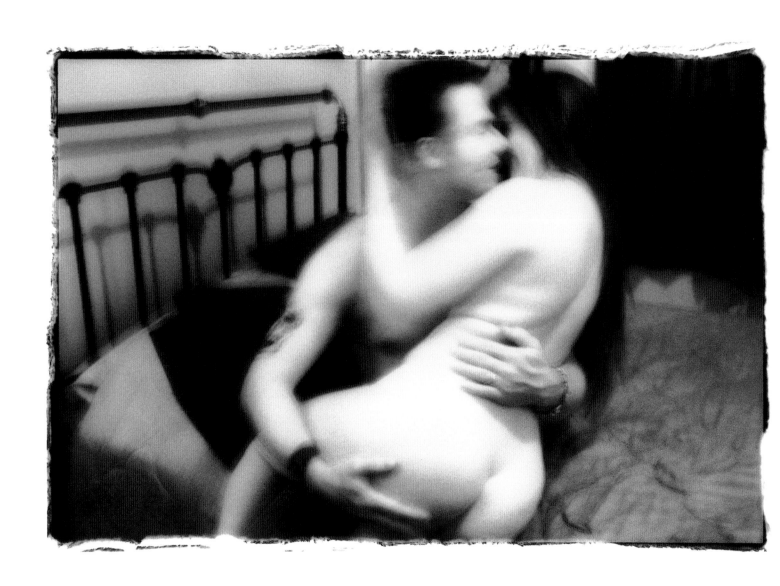

Kelly and Susan, I

22

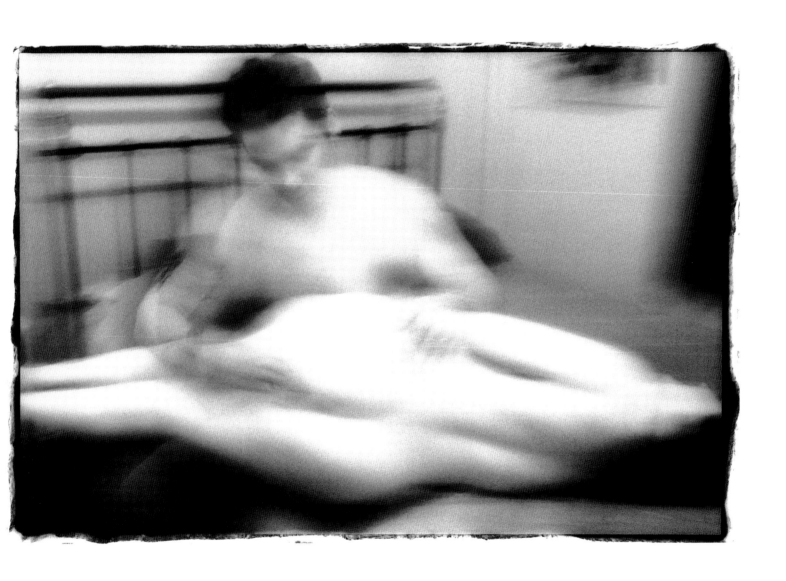

Kelly and Susan, II

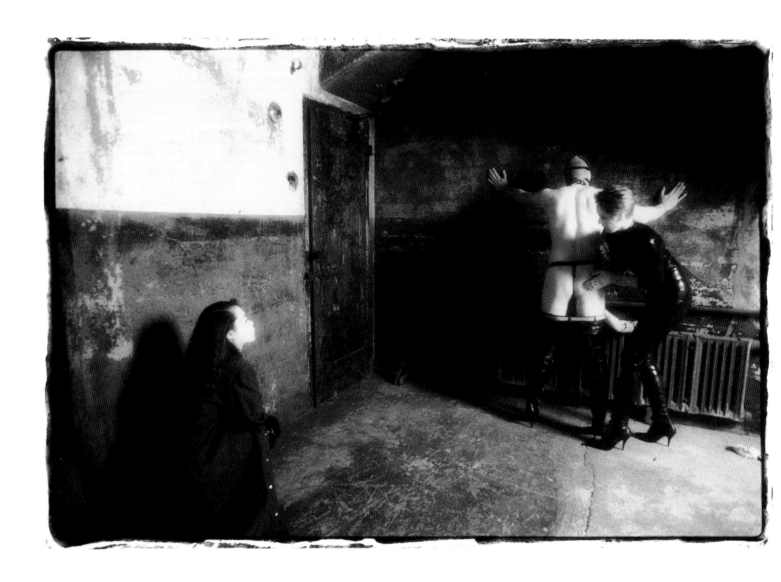

Voyeur

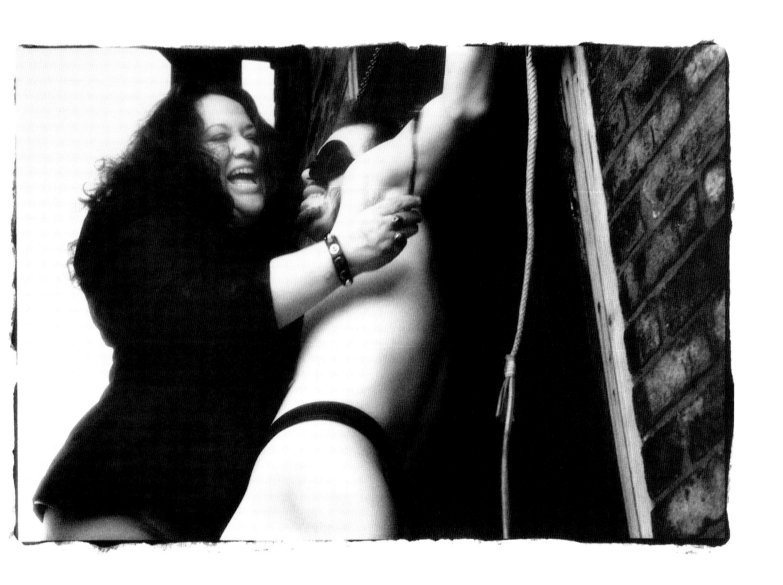

Velvet and Thrash, I

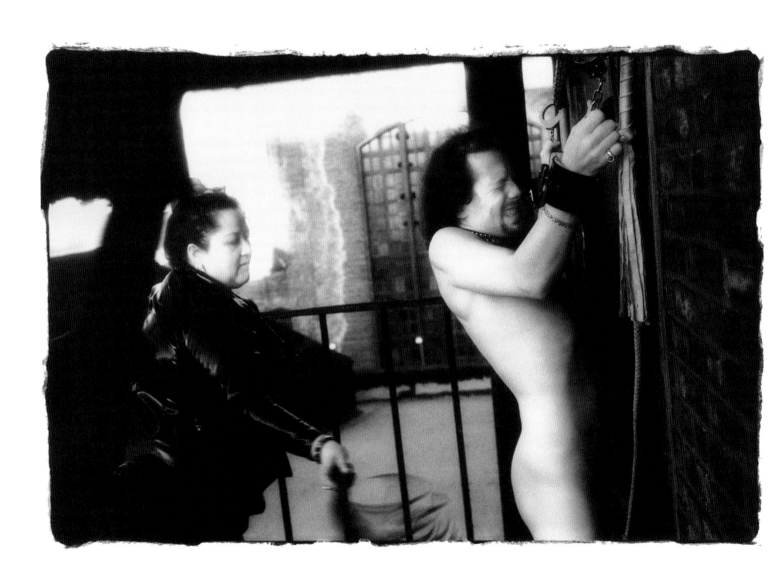

Velvet and Thrash, II

26

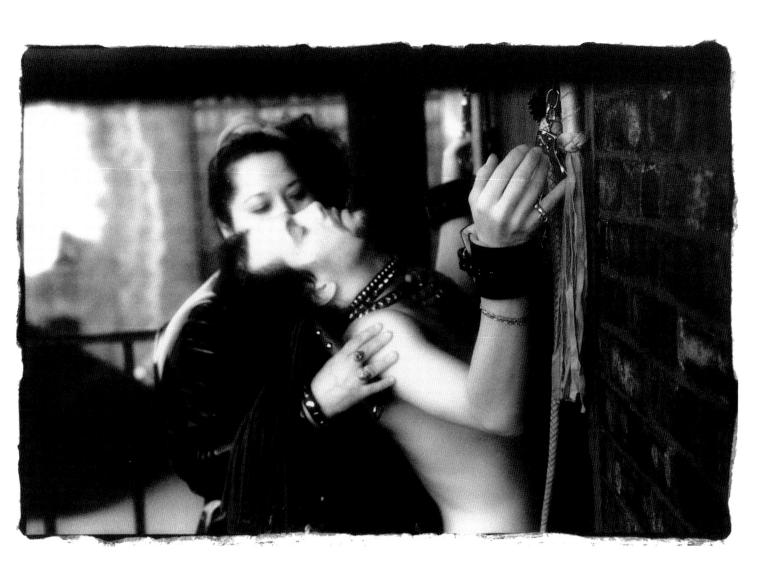

Velvet and Thrash, III

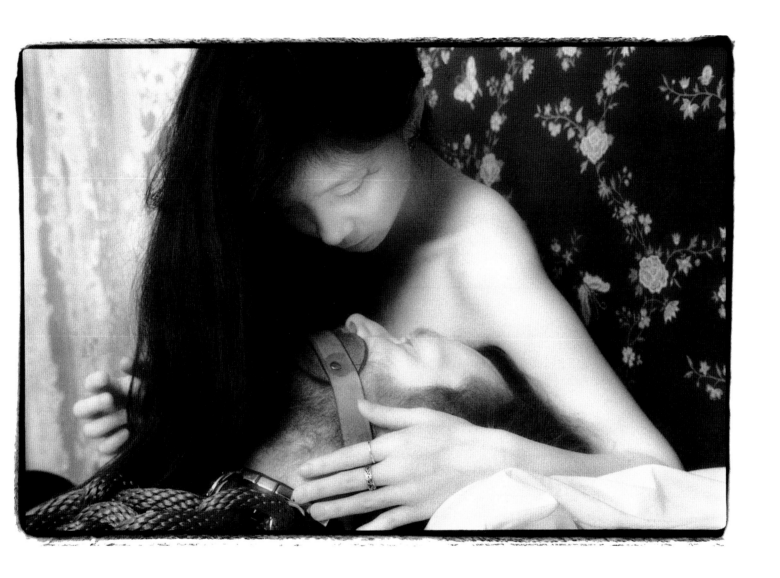

Madame and mine

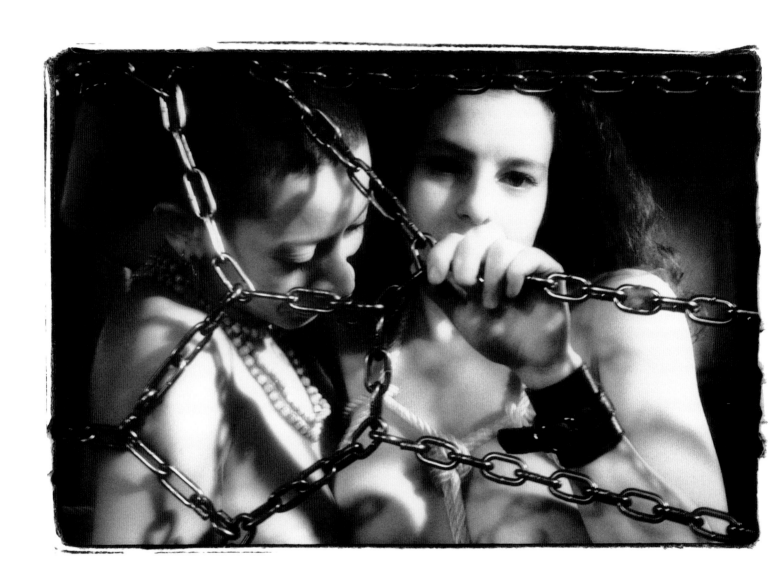

Velma and Elissa, III

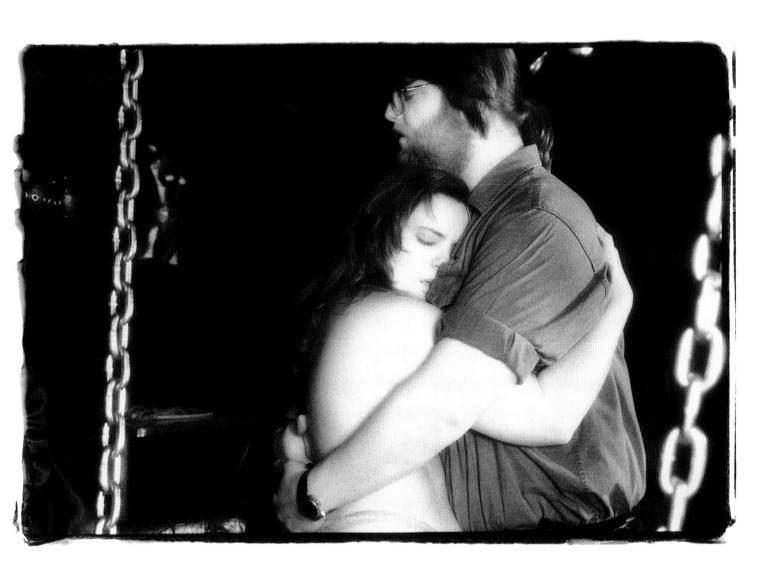

Soulhuntre and Kimiko

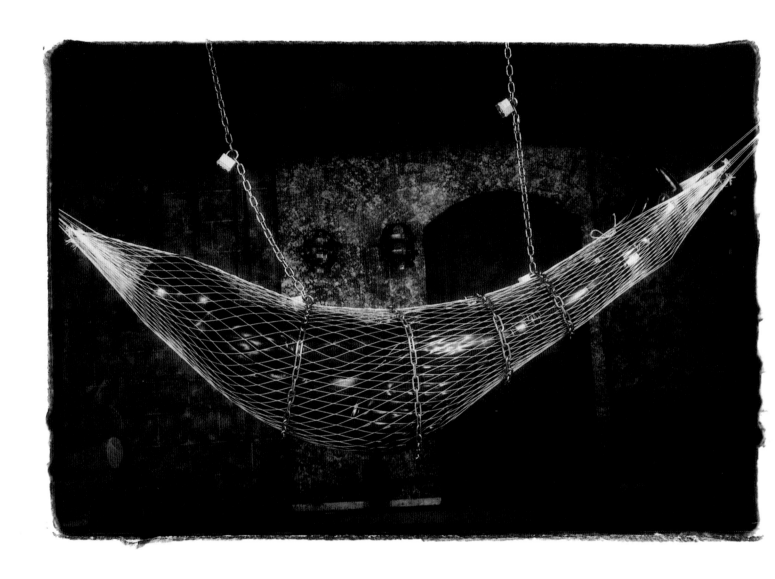

Jack at Home

32

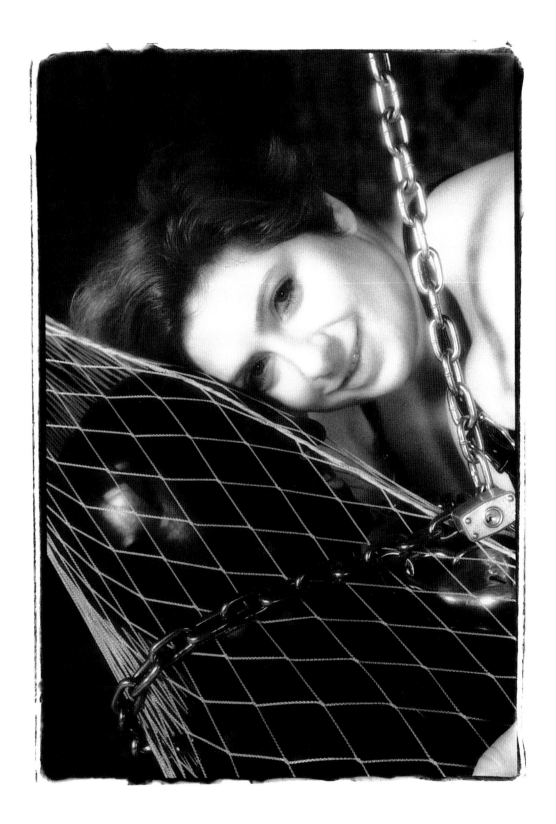

Jack and Lolita, II

33

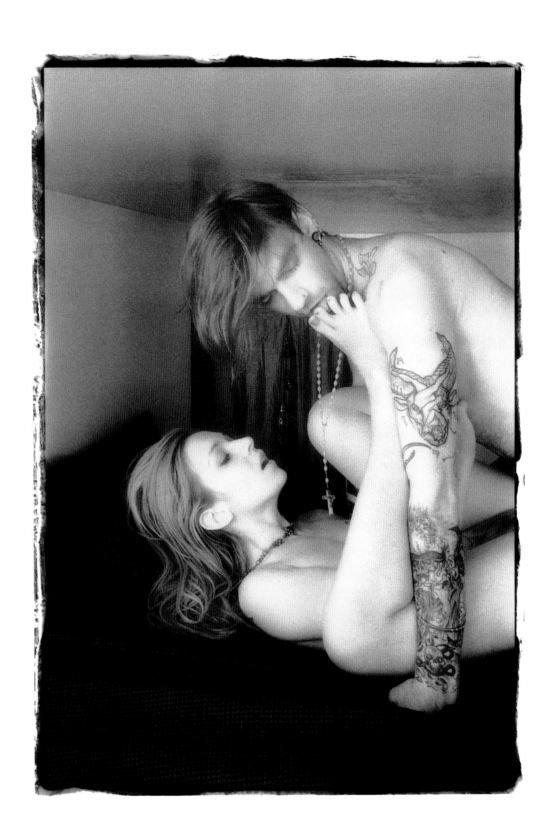

Popsicle Toes

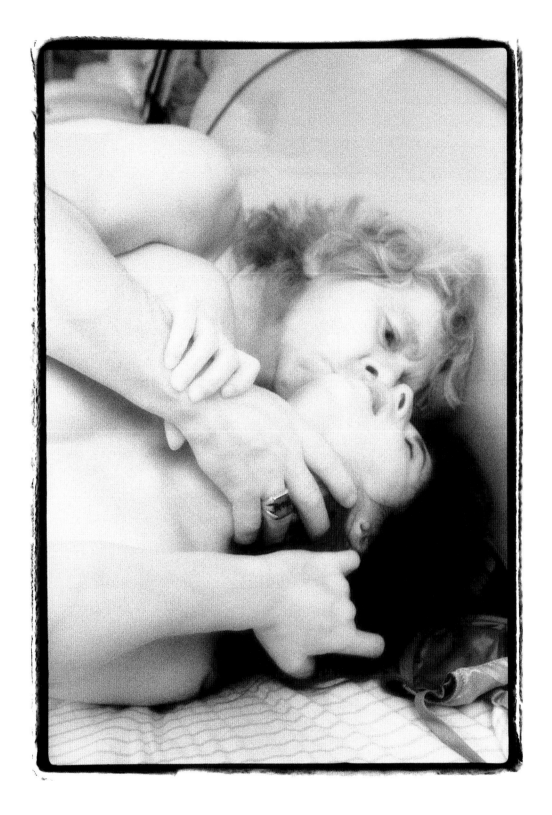

Neville and Sarah

35

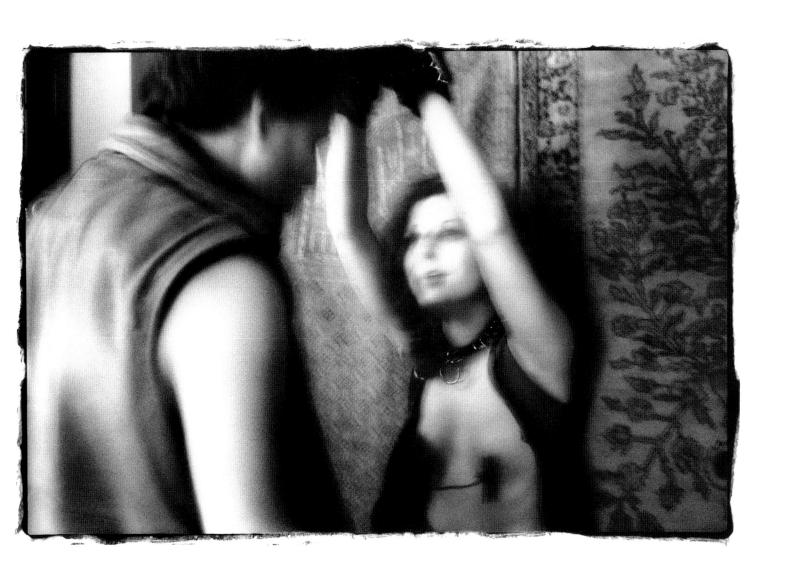

Chris's Dungeonette

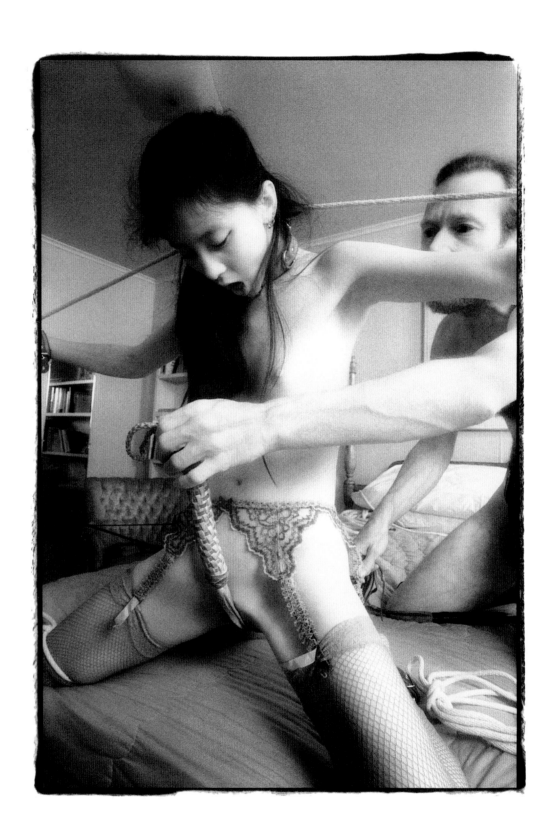

Master R and Sang, I

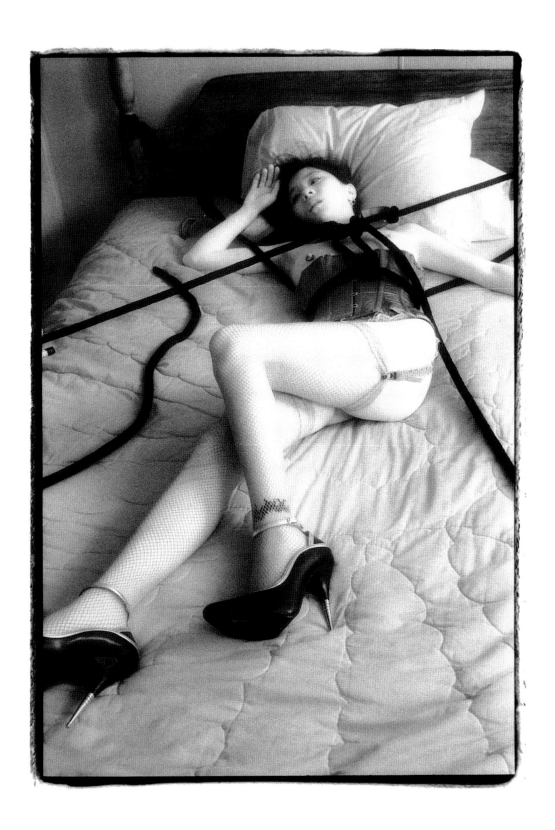

All Slaved Out

39

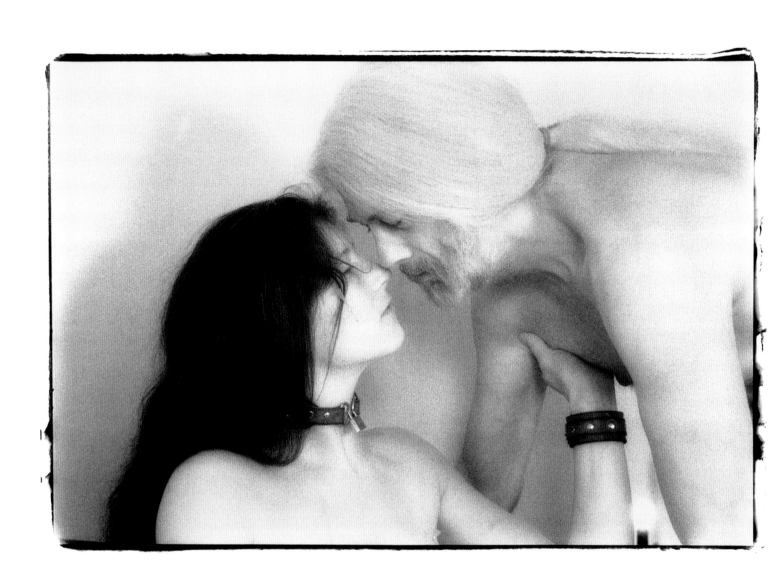

Play Piercing, I

40

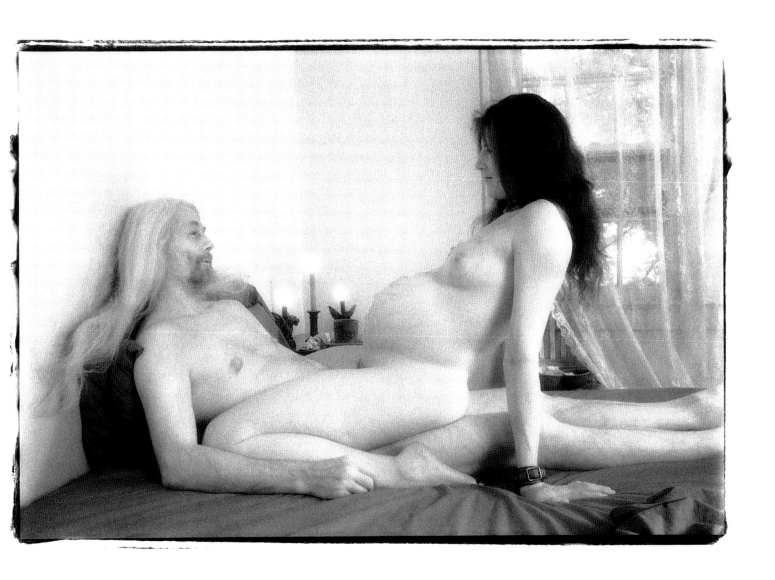

Play Piercing, IV

41

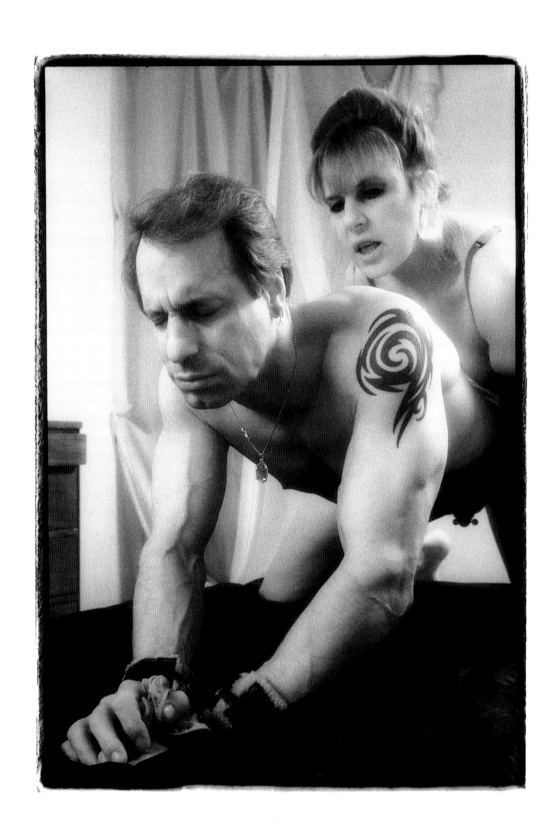

Nona and Mark

Tam and Kit

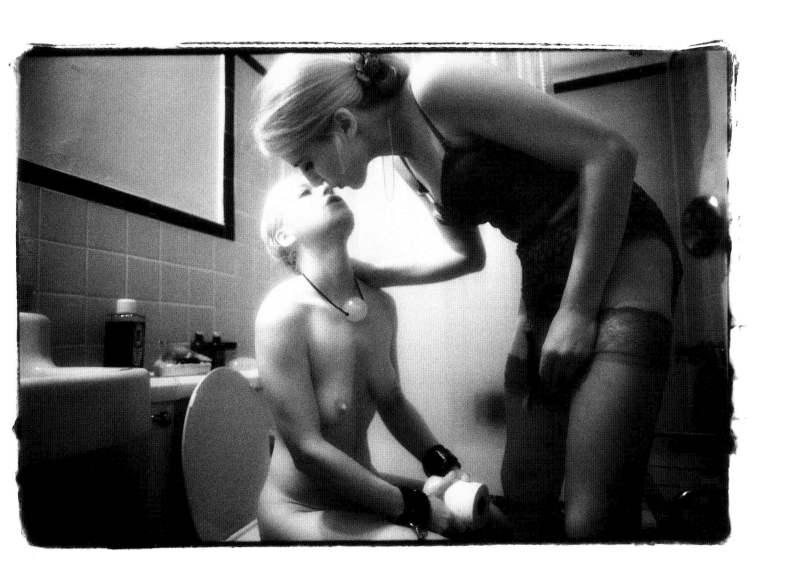

Bathroom Kiss

45

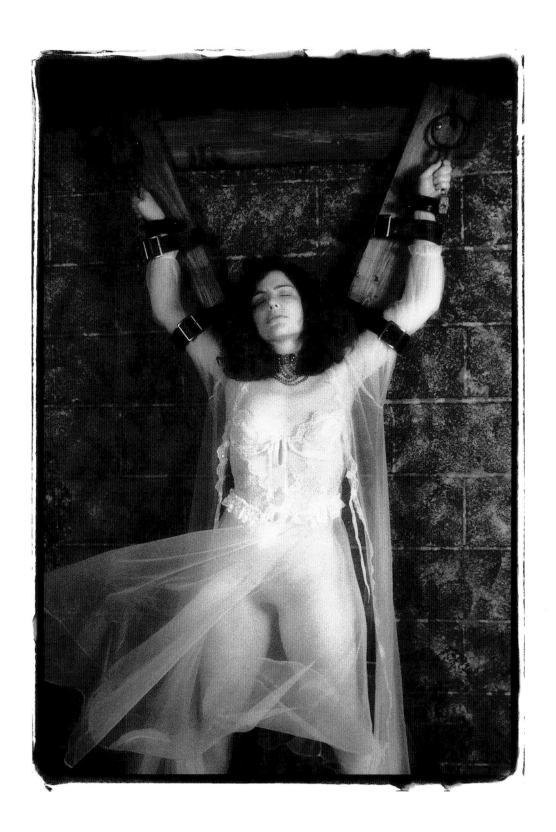

Rusty's Dream

46

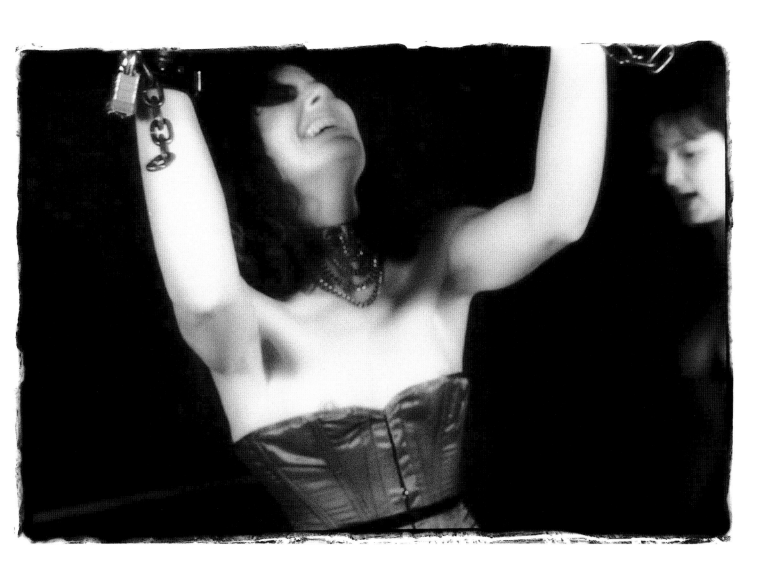

Laura's Dream

47

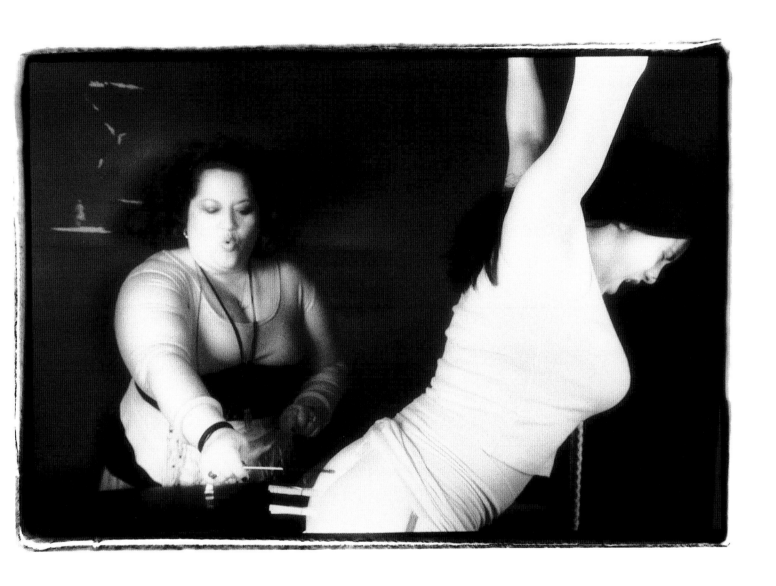

Antonia in Heaven

49

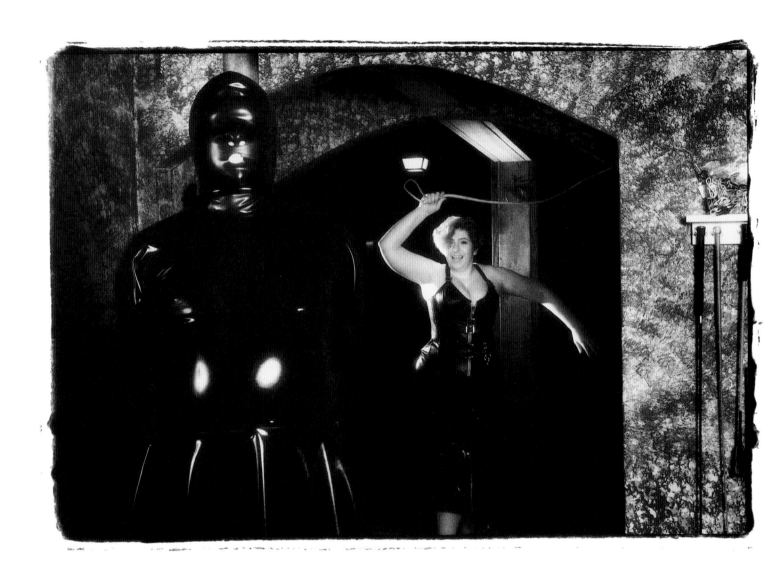

Jack and Lolita, I

50

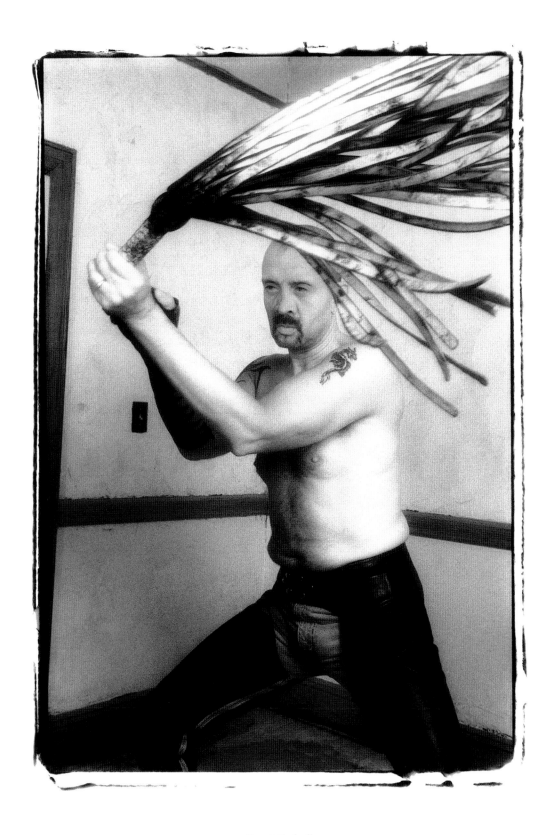

Jim Mitchell

51

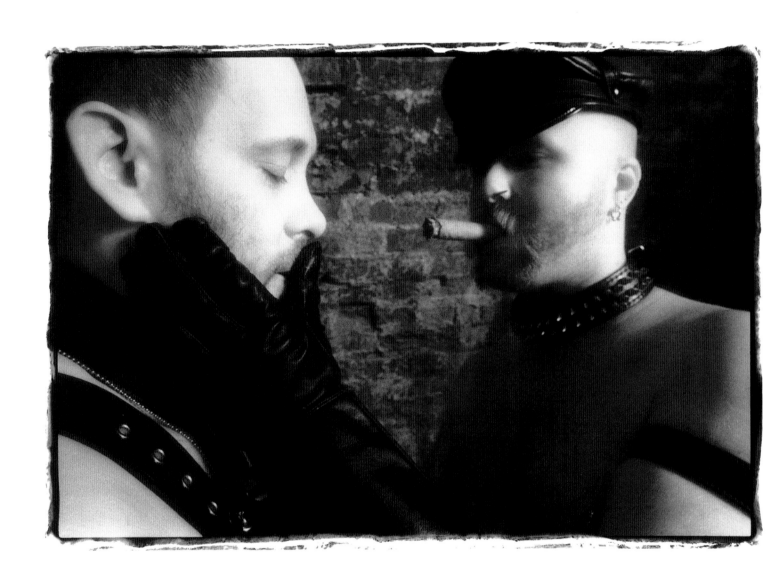

Brian and Jaz, I

52

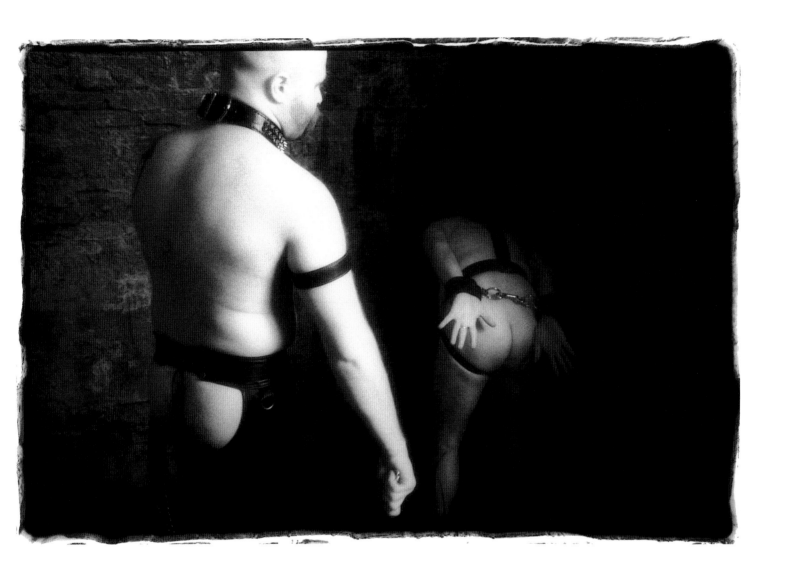

Brian and Jaz, II

53

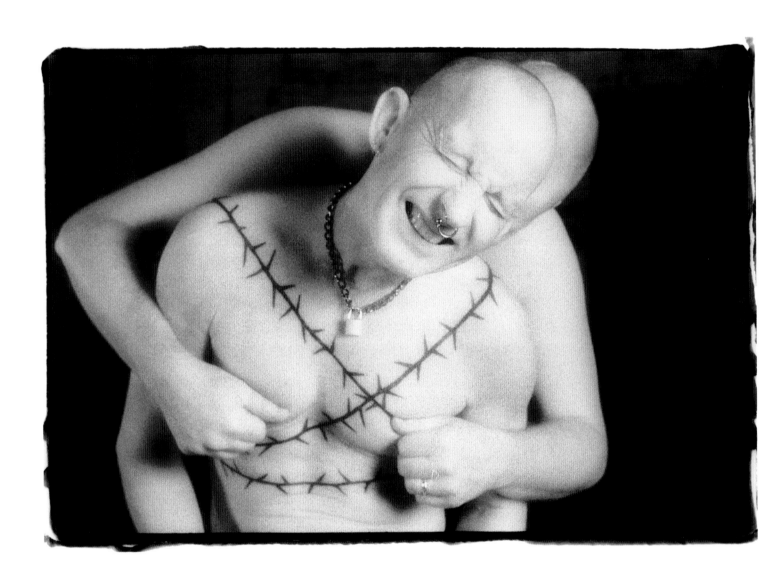

Gary and wynn, I

54

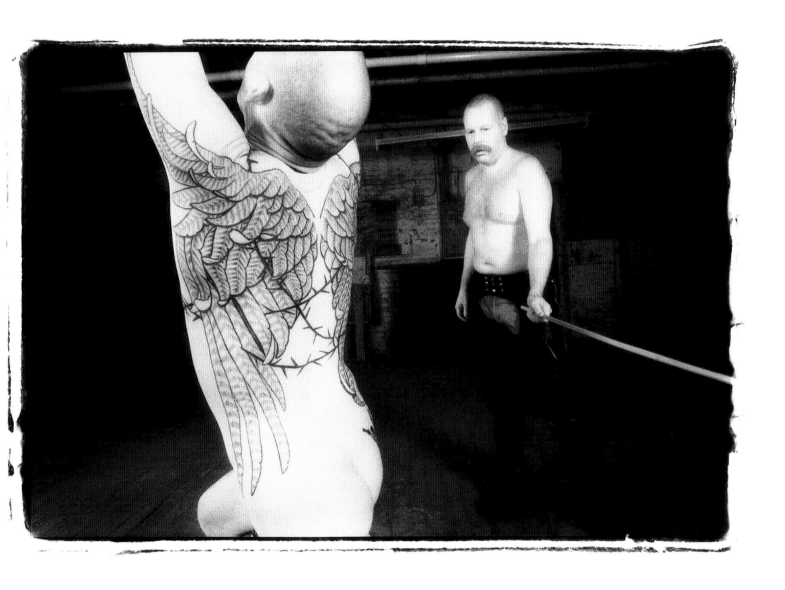

Gary and wynn, II

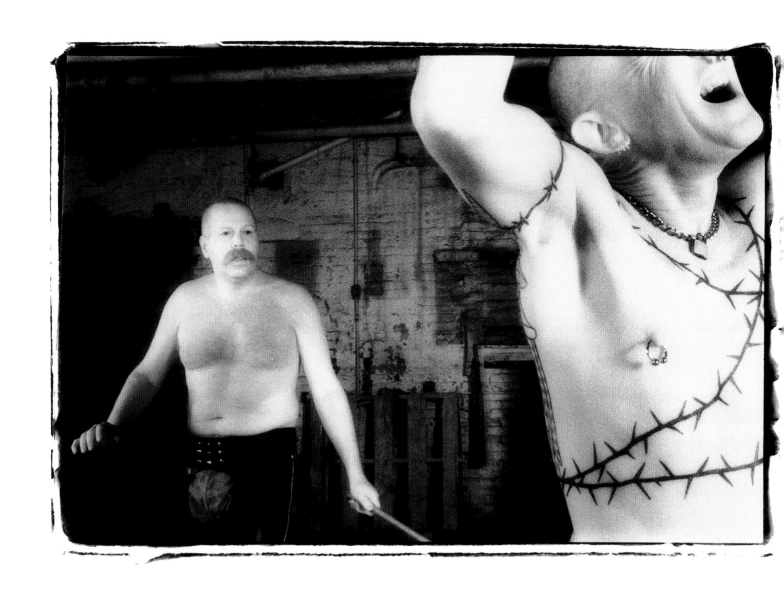

Gary and wynn, III

56

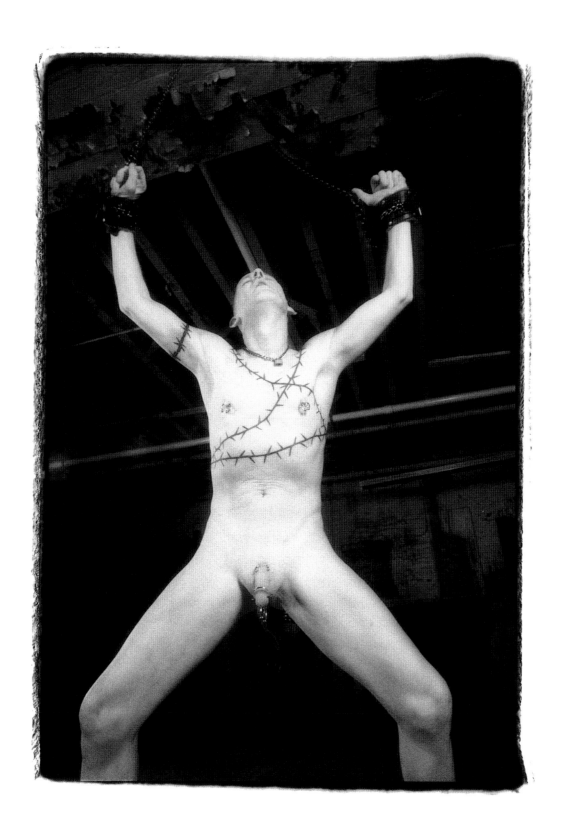

Gary and wynn, IV

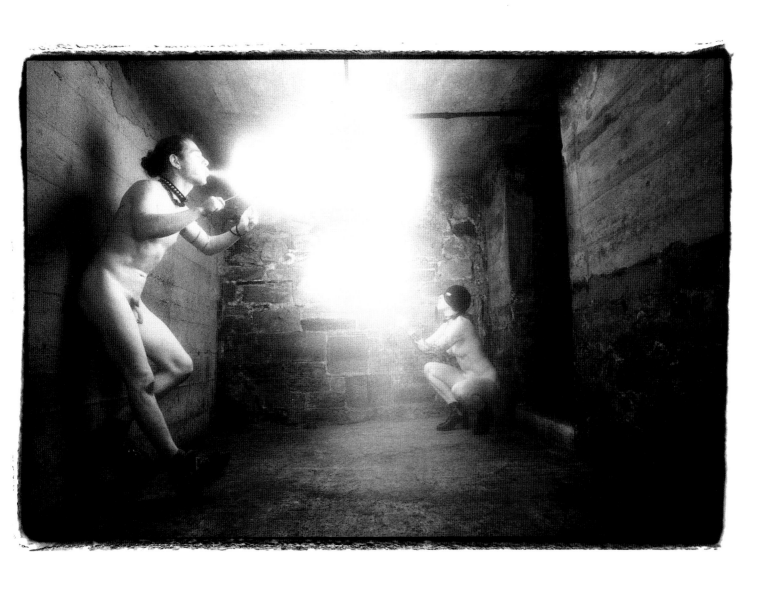

Keith and Stephanie, Blowing

59

Sir C

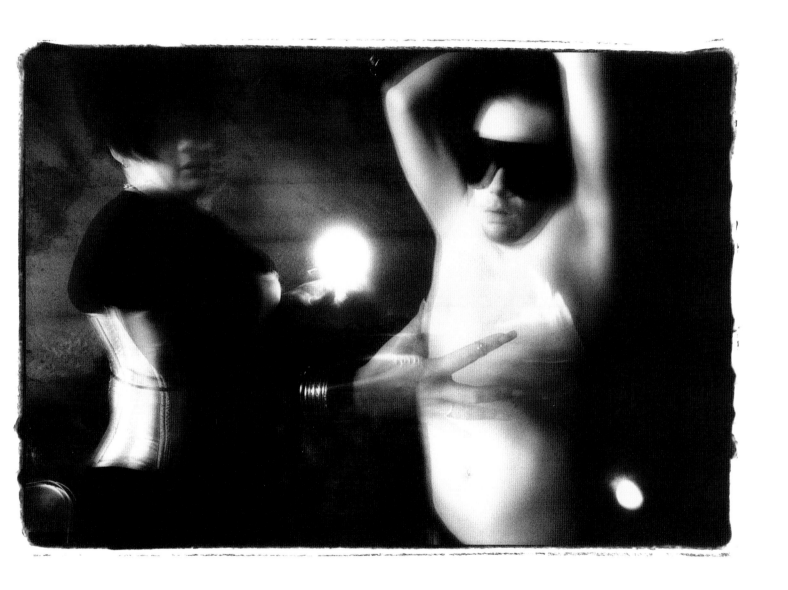

Sir C and Thrash

61

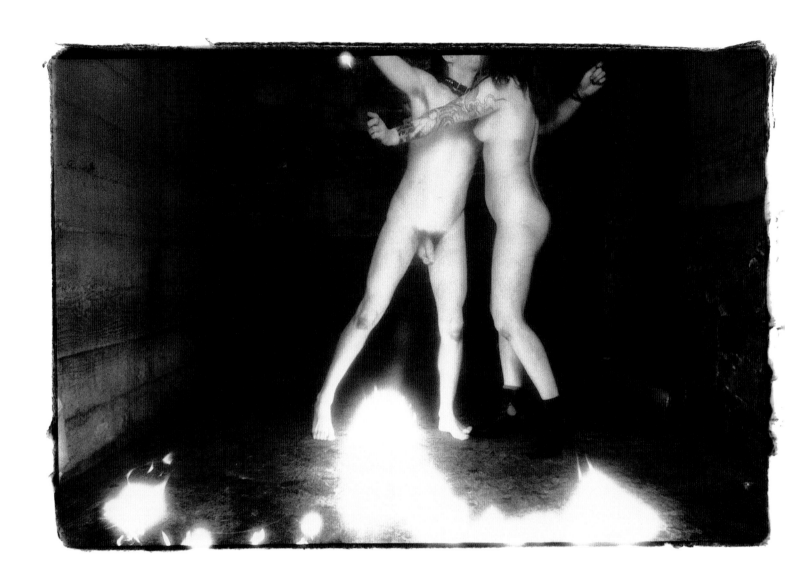

Fireplayers, II

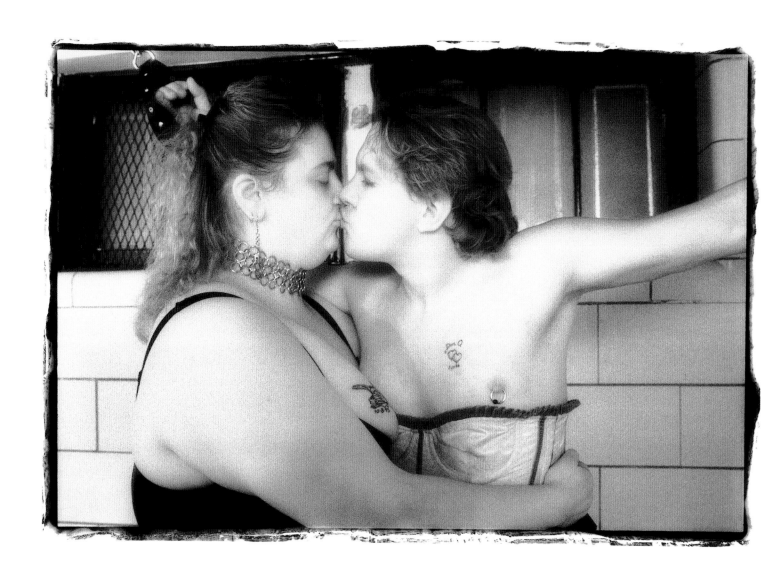

Don and Susie Q, I

64

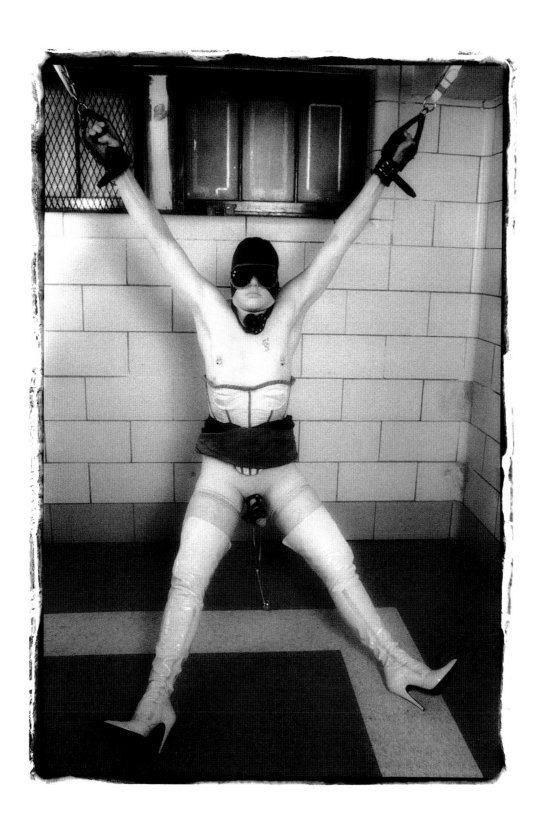

Don and Susie Q, III

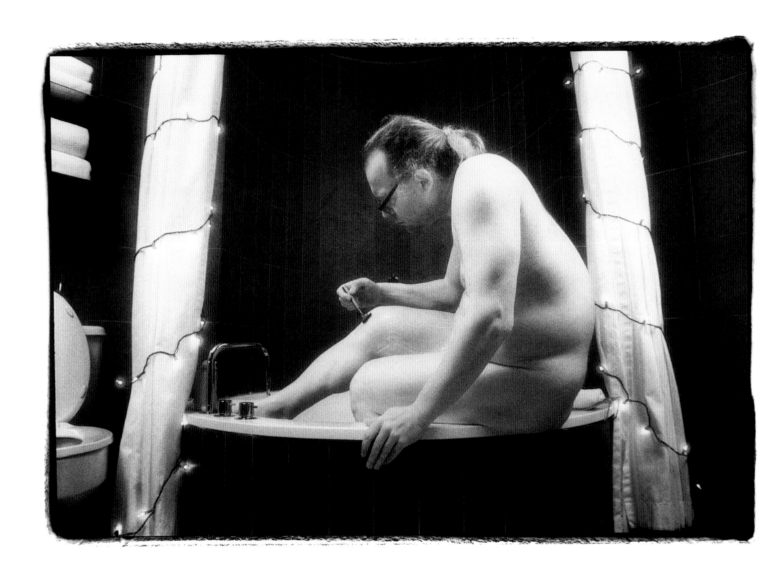

The Long Shave

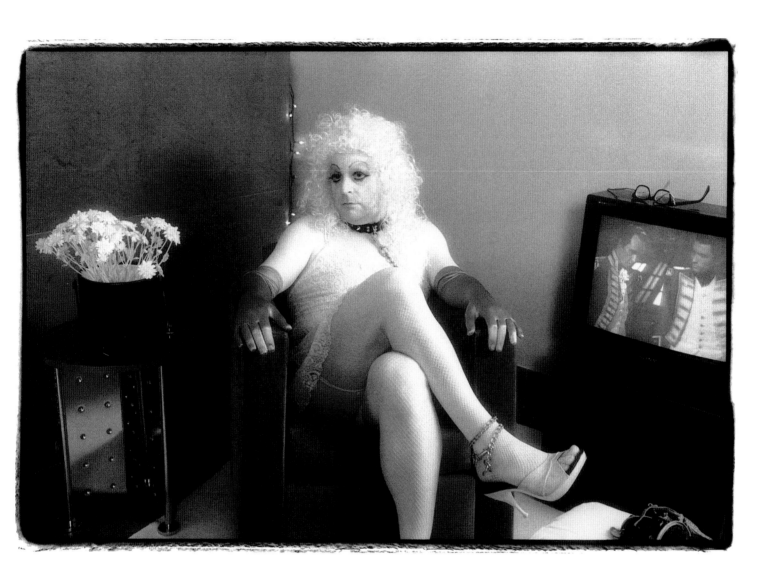

The Fabulous Pet

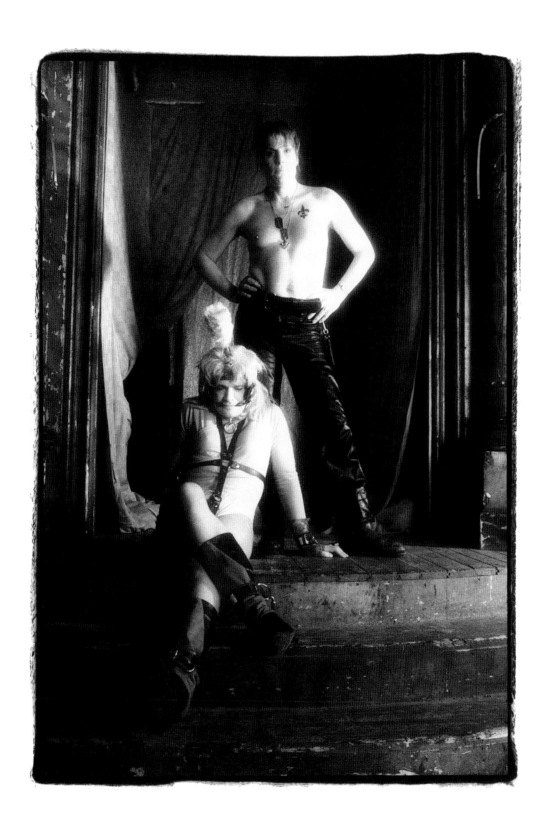

Master Fred's Last Stand

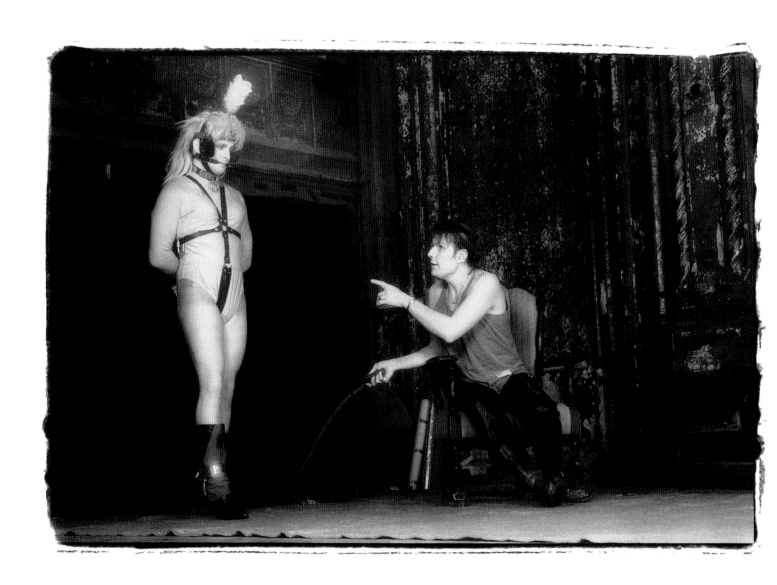

Pony Training, I

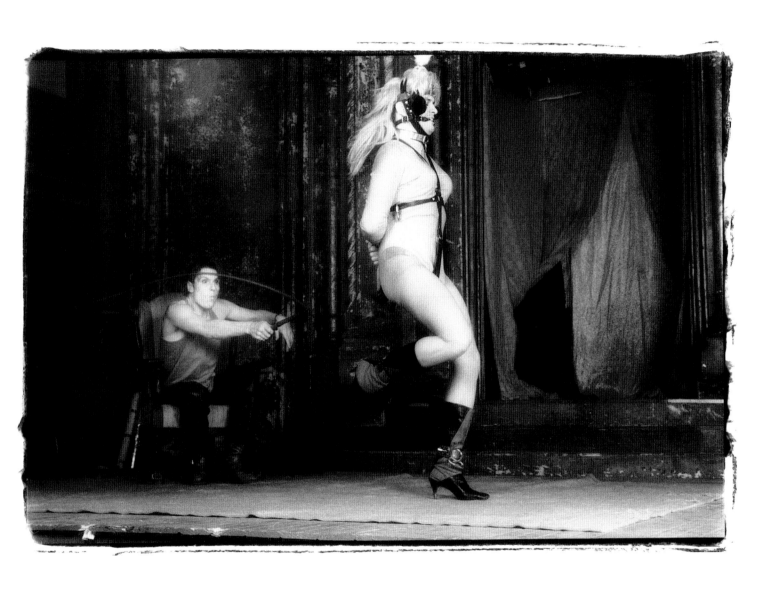

Pony Training, II

71

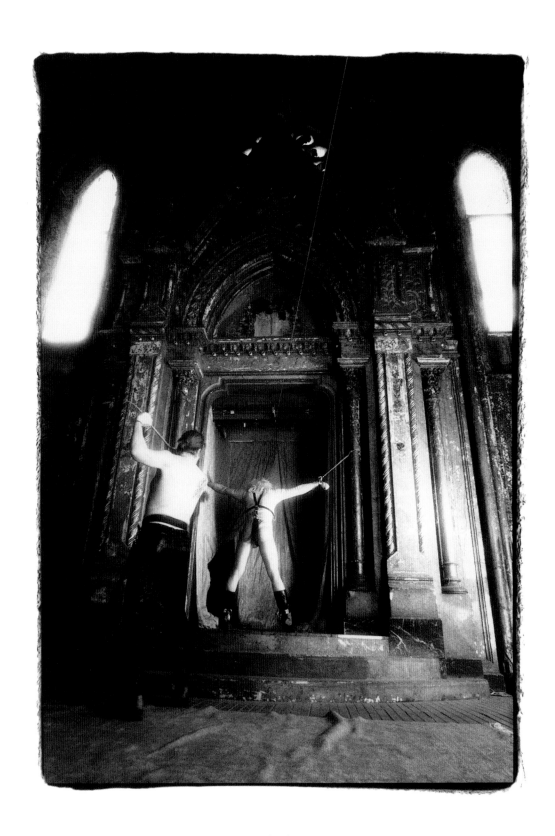

Signal Whip, I

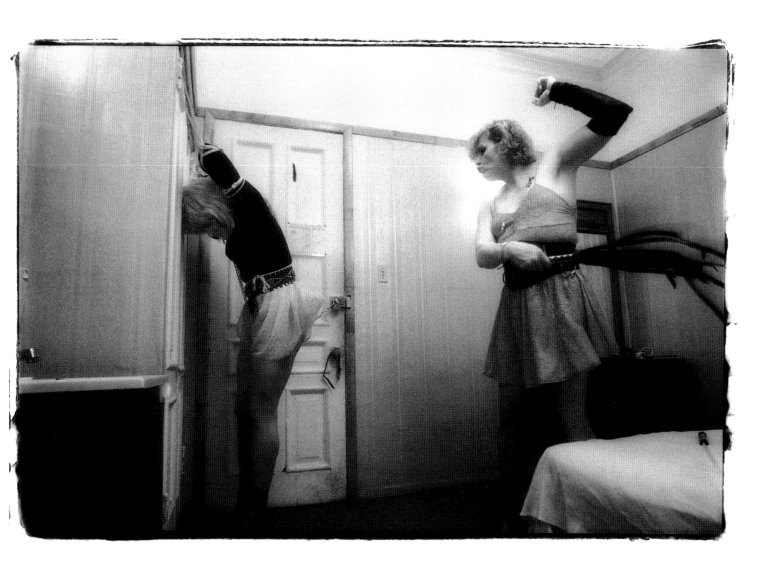

April and Monica at the Hotel 17, I

73

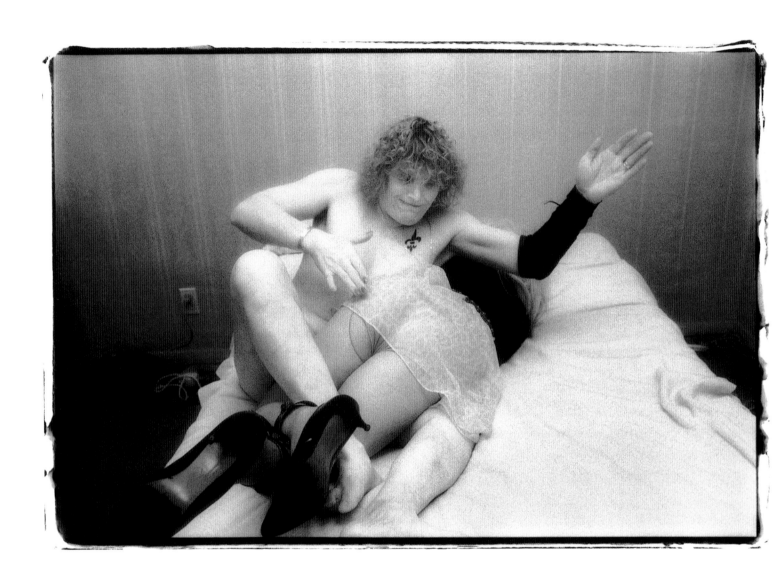

April and Monica at the Hotel 17, II

74

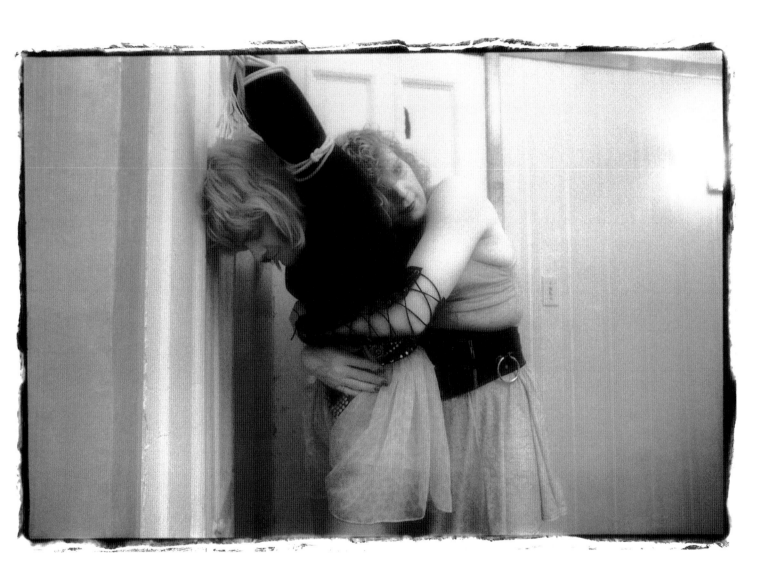

April and Monica at the Hotel 17, III

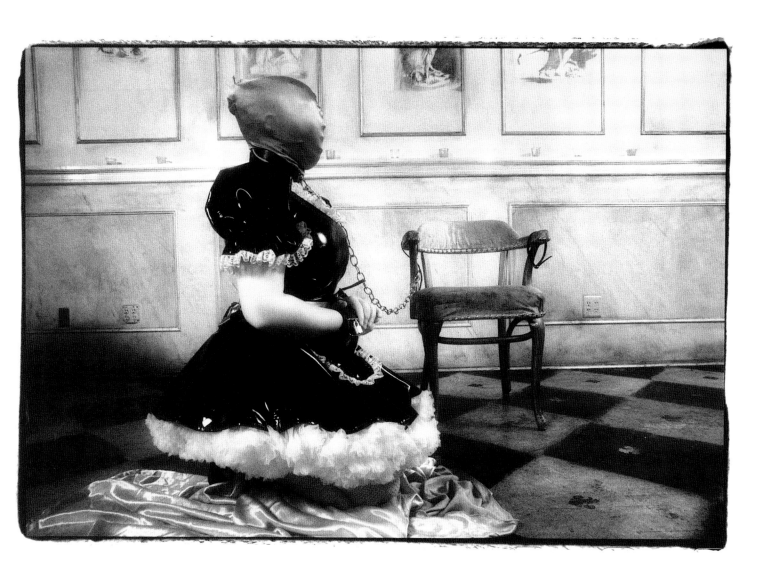

Zoe

77

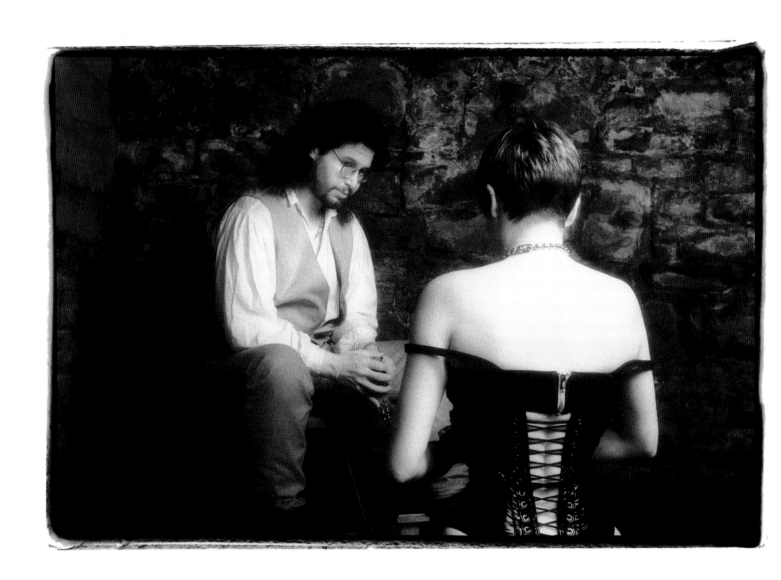

Flagg and Tink

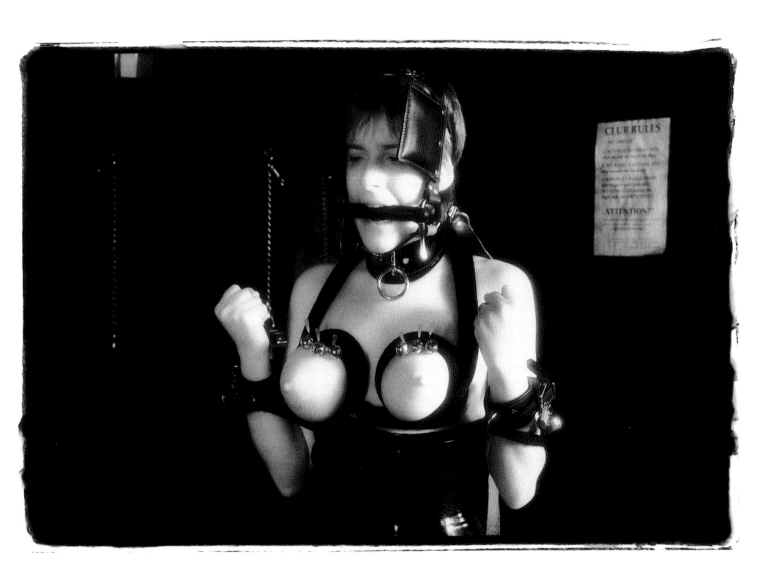

Tink and the Club Rules

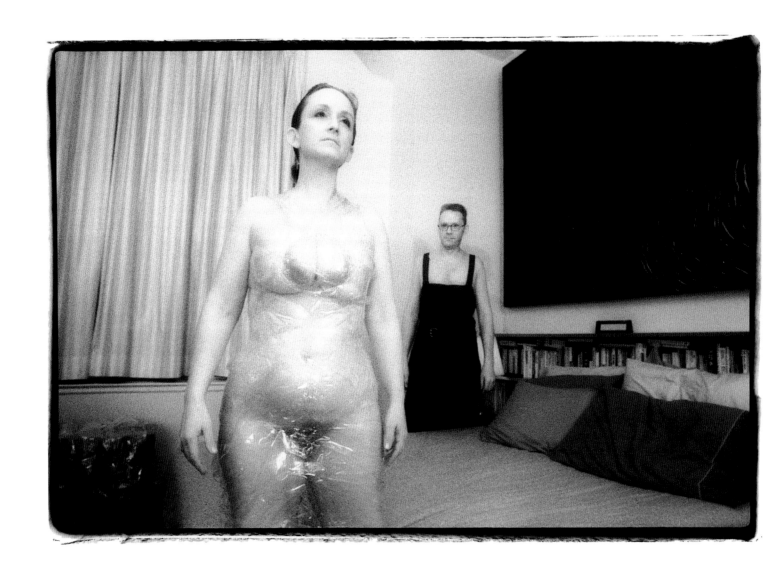

Rob and Lisa

80

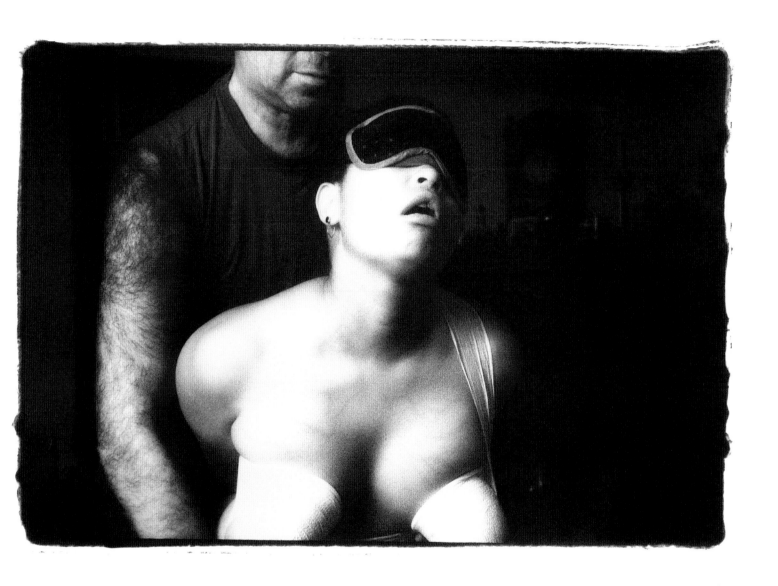

Leonard and Michele, I

81

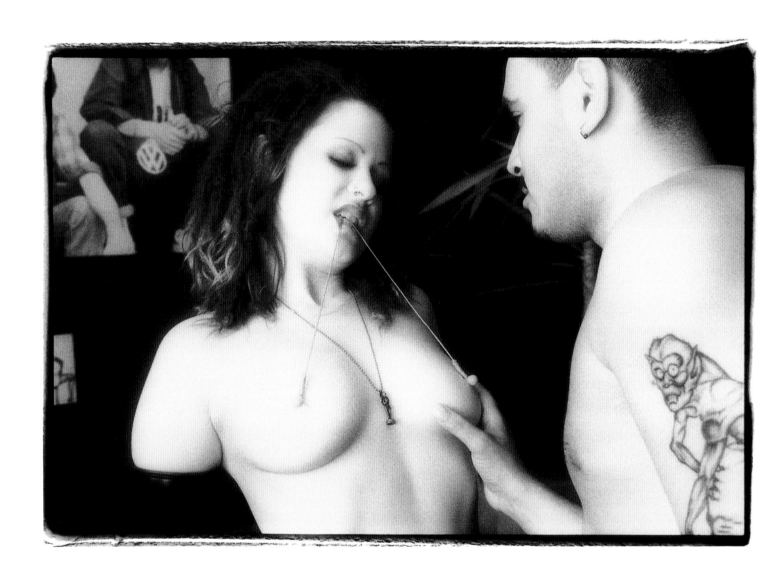

Angelbaby and G. A.

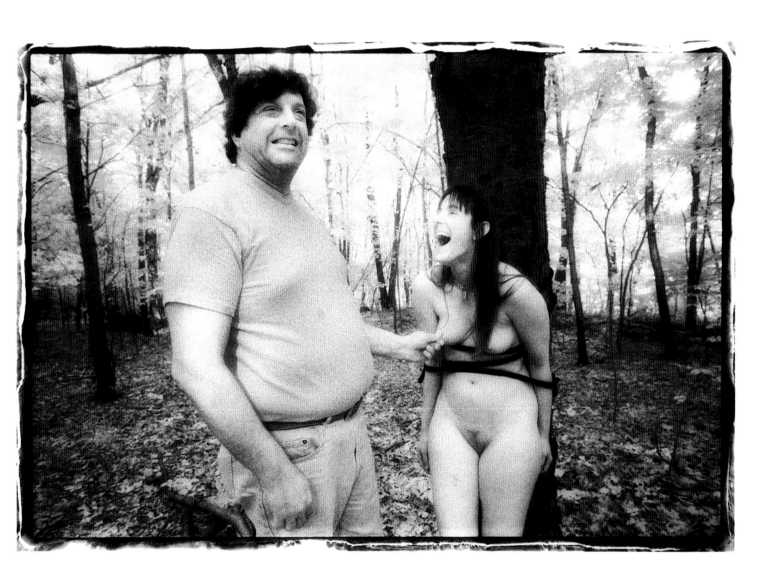

Bob and Ann

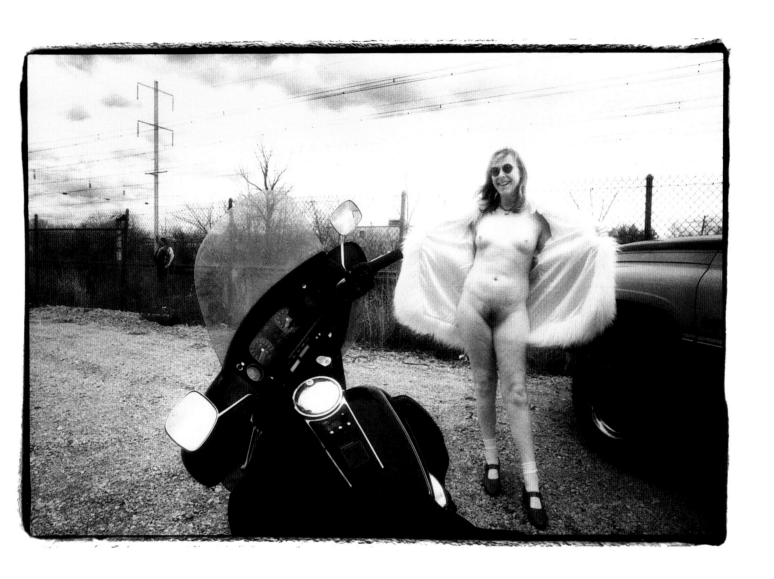

Vixen

85

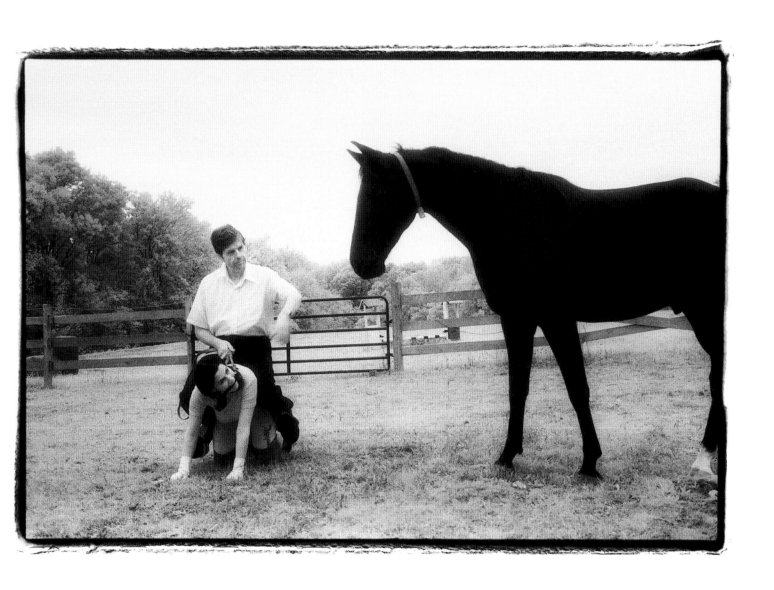

Horse Farm

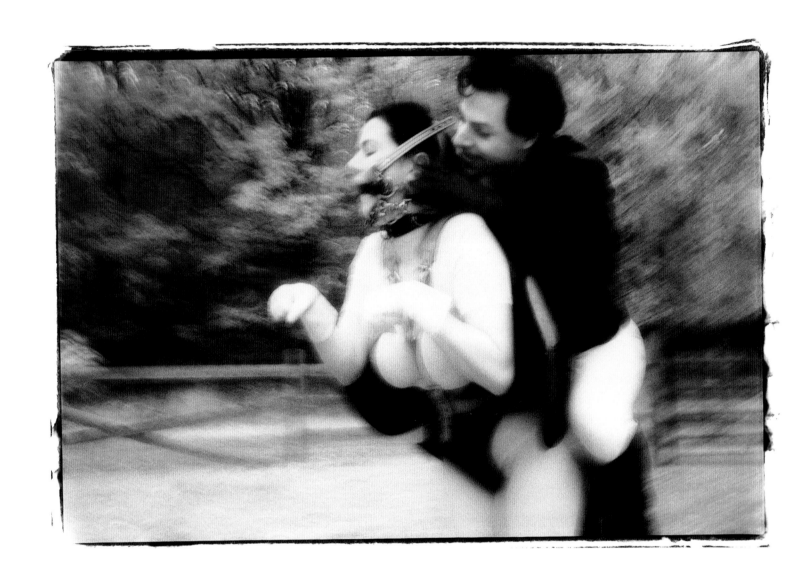

Piper and MacKenzie, I

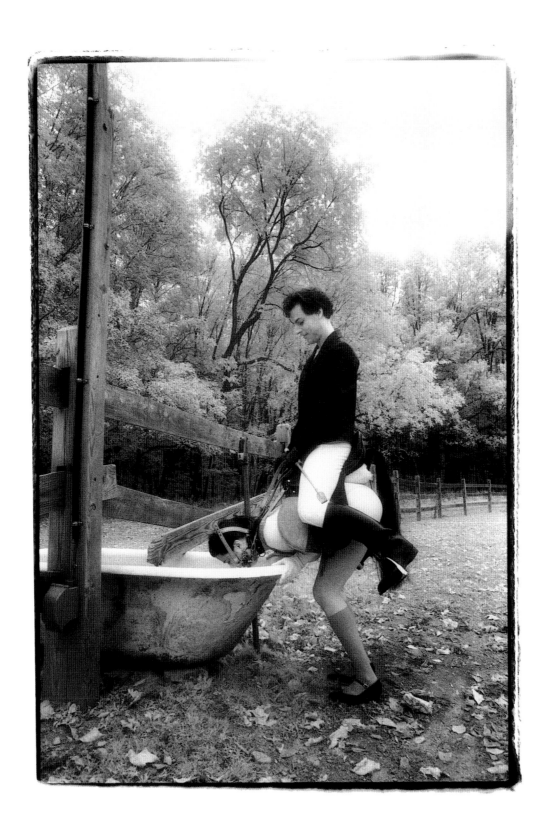

Piper and MacKenzie, II

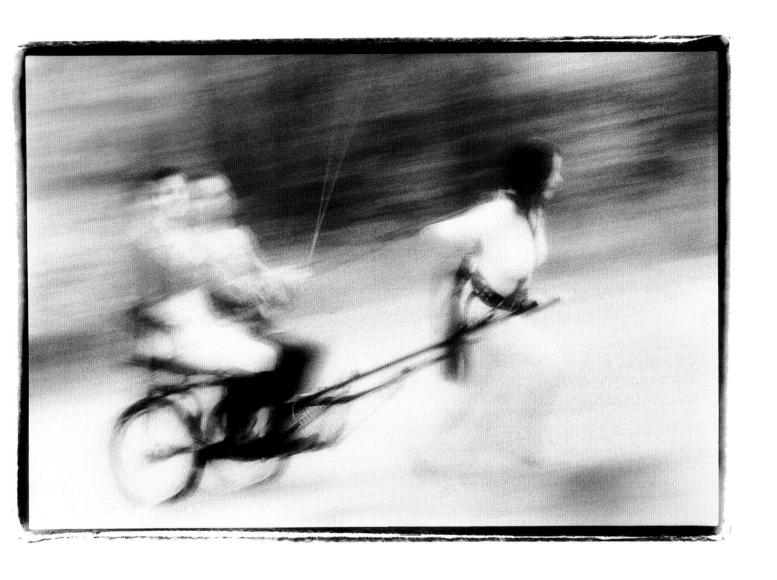

Happily Ever After

page 19 *Mark and Velma*

Velma tied to a cross and teasing her husband Mark. She's famous for being a smart ass masochist, or SAM. Once at a party someone ran to get me to come and see Velma tied up and completely immobilized. By the time I got there, she had wiggled out.

page 21 *Velma and Elissa, I*

They are both predominately het, but sometimes play with women. They had wanted to play with each other for quite some time, and did it for the first time for me.

page 22 *Kelly and Susan, I*

Kelly spanking Susan in their bedroom shortly after their marriage. She's a well-known writer and activist for leather community rights.

page 23 *Kelly and Susan, II*

I was amazed to find out that they were both born on the exact same day in 1963. Kelly saw her on a television talk show and instantly knew that she was his soulmate. He joined her SM group just to meet her.

page 24 *Voyeur*

This is the photograph that I have hanging above my desk. When I saw Leda watching Carrie give the spanking, it reminded me of myself out on a Saturday night at the clubs. I have always had tremendous curiosity about people, so to find a community that would honor my curiosity, and allow me to openly express my voyeurism among them is exhilarating.

page 25 *Velvet and Thrash, I*

I met them at the beginning of their relationship, and originally thought they were both tops. He's a natural whip artist and loves to walk down the street cracking a single tail. She has a regal quality that is very compelling.

page 26 *Velvet and Thrash, II*

We shot this out on a fire escape at my friend Brian's loft in New

Seite 19 *Mark und Velma*

Velma, an ein Kreuz gebunden, ihren Mann Mark stichelnd. Sie ist eine Masochistin der spöttischen Sorte, genannt »smart ass masochist« (SAM). Einmal auf einer Party kam jemand angerannt und holte mich: Ich sollte mir Velma anschauen, die gefesselt und völlig bewegungsunfähig sei. Als ich am Schauplatz eintraf, hatte sie sich schon aus eigener Kraft befreit.

Seite 21 *Velma und Elissa, I*

Sie sind beide überwiegend hetero, spielen aber manchmal mit Frauen. Schon seit einiger Zeit hatten sie miteinander spielen wollen und taten es für mich zum ersten Mal.

Seite 22 *Kelly und Susan, I*

Kelly, Susan züchtigend, in ihrem Schlafzimmer kurz nach ihrer Heirat. Sie ist eine namhafte Autorin und Aktivistin für die Rechte der Leder-Community.

Seite 23 *Kelly und Susan, II*

Unglaublicher Zufall: Ich fand heraus, dass beide 1963 am selben Tag zur Welt gekommen sind. Kelly sah Susan in einer Talkshow im Fernsehen und wusste sofort: Die oder keine. Er trat in ihre SM-Gruppe ein, nur um sie kennen zu lernen.

Seite 24 *Voyeur*

Dies ist das Foto, das über meinem Schreibtisch hängt. Als ich zusah, wie Leda Carrie beim Züchtigen zuschaute, fühlte ich mich erinnert an meine eigene Rolle als Zaungast samstagabends in den Clubs. Seit jeher bin ich ungeheuer neugierig auf Menschen; deshalb war es beflügelnd, eine Community zu finden, die meine Neugier honorierte und mir erlaubte, meinen Voyeurismus offen auszuleben.

Seite 25 *Velvet und Thrash, I*

Ich lernte sie am Anfang ihrer Beziehung kennen und hielt sie anfangs beide für Tops. Er ist ein geborener Peitschenkünstler und liebt es, die Straße hinabzuschlendern und mit einer Einschwänzigen zu knallen. Sie hat eine bezwingende, königliche Art.

Jersey. Later we found out that we were in full view of a strip mall parking lot.

page 27 *Velvet and Thrash, III*
Often my favorite shot comes in the moments after a scene. They melt into each other, wrapped in a delicious golden glow.

page 29 *Madame and mine*
When we looked at the contact sheets, all three of us knew that this was our shot. When he submits to her she calls him simply, »mine«. No name. They own a training chateau and getaway in upstate New York.

page 30 *Velma and Elissa, III*
A quiet moment after flogging. Both women are highly regarded writers in the scene – Elissa, for her personal memoirs and Velma, for SM erotica.

page 31 *Soulhuntre and Kimiko*
After a cathartic scene, which included piercing and whipping, she began to sob. Deeply embarrassed, she asked us later if that was okay.

page 32 *Jack at Home*
Jack enjoys long-term bondage. For the shoot, Lolita dressed him in head-to-toe rubber and sewed him into a hammock, which she then wrapped in chains and locked.

page 33 *Jack and Lolita, II*
After locking him in, she kissed him through the rubber hood. Then she looked into the camera, her face radiant. Someone once told me that when you're photographing people, sometimes they give you a gift. This was one of those moments for me.

page 34 *Popsicle Toes*
This was a spontaneous moment during sex in their loft bed. I was up on a ladder on the other side of the tiny room photographing them.

Seite 26 *Velvet und Thrash, II*
Diese Fotosession machten wir auf der Feuerleiter am Loft meines Freundes Brian in New Jersey. Später stellten wir fest, dass wir vom Parkplatz eines Einkaufszentrums aus deutlich zu sehen gewesen waren.

Seite 27 *Velvet und Thrash, III*
Mein Lieblingsfoto kommt oft in den Augenblicken nach einer Szene. Das Paar verschmilzt miteinander, in zartes goldenes Licht gehüllt.

Seite 29 *Madame und mine*
Als wir uns die Kontaktabzüge anschauten, wussten wir drei sofort, dass uns diese Aufnahme am besten gefällt. Wenn er sich ihr unterwirft, nennt sie ihn einfach »mine«. Kein Name. Sie besitzen ein Chateau als Schulungsort und Refugium im Norden des Staates New York.

Seite 30 *Velma und Elissa, III*
Ein stiller Augenblick nach dem Flogging. Beide Frauen sind als Autorinnen in der Szene hochgeachtet – Elissa für ihre Memoiren, Velma für ihre SM-Erotika.

Seite 31 *Soulhuntre und Kimiko*
Nach einer kathartischen Szene mit Piercing und Auspeitschen fing sie an zu schluchzen. In tiefer Verlegenheit fragte sie uns später, ob uns das etwas ausgemacht hätte.

Seite 32 *Jack daheim*
Jack genießt Langzeit-Bondage. Für die Sitzung kleidete ihn Lolita von Kopf bis Fuß in Leder und nähte ihn in eine Hängematte ein, die sie mit Ketten umwickelte und mit Vorhängeschlössern verschloss.

Seite 33 *Jack und Lolita, II*
Nachdem sie ihn eingeschlossen hatte, küsste sie ihn durch die Gummihaube. Dann blickte sie verträumt strahlend in die Kamera. Jemand hat mir einmal gesagt: Wenn du Leute fotografierst, schen-

page 35 *Neville and Sarah*
Also a spontaneous moment. He had tied her up and paddled her as
a form of foreplay before sex. Until that moment, I didn't realize
they also practiced breath control.

page 37 *Chris's Dungeonette*
Chris and Bernadette playing in the minimalist dungeon in his
home. He's both an artist and an art collector. Before we began the
scene, he meticulously thought out which photos should be on dis-
play in the room.

page 38 *Master R and Sang, I*
Madame Sang was comfortable being seen as a dominant for my
camera, but she thought she would be too vulnerable submitting. It
took her a year to decide to allow me to come back and take these
photographs.

page 39 *All Slaved Out*
At the end of scene, Sang laid back on the bed and sighed, »Oh, I'm
just all slaved out.«

page 40 *Play Piercing, I*
Ivan and Ann have a spiritual connection that is breath taking. They
are both over six feet tall, and when I asked to photograph them,
they wordlessly stood on each side of me and kissed over my head.

page 41 *Play Piercing, IV*
She waited until she was eight and a half months pregnant to do the
shoot. She also checked with her doctor to see what types of SM
play were safe for the baby. During the scene, she indicated where
Ivan should place each hypodermic needle – they form a circle
around her belly and also around each breast – and then they unex-
pectedly made love.

page 42 *Nona and Mark*
When Nona wanted to learn fisting, she apprenticed herself to a
well-known gay leatherman. She practiced under his direction un-
til she felt confident enough to do it at home on her own.

ken sie dir manchmal etwas. Dies, hier und jetzt, war mein Ge-
schenk.

Seite 34 *Eis am Stiel*
Ein spontaner Augenblick beim Sex in ihrem Hochbett. Ich stand
an der gegenüberliegenden Wand des Zimmerchens auf einer Lei-
ter und fotografierte sie.

Seite 35 *Neville und Sarah*
Ebenfalls ein spontaner Augenblick. Er hatte sie gefesselt und mit
dem Paddle aufgewärmt als Vorspiel vor dem Sex. Bis dahin war mir
nicht klar gewesen, dass sie auch Atemkontrolle praktizierten.

Seite 37 *Chris' Dungeonette*
Chris und Bernadette spielen in dem minimalistischen Verlies in
seinem Haus. Er ist Künstler und Kunstsammler. Ehe wir die Szene
starteten, überlegte er sich genau, welche Fotos im Zimmer zu se-
hen sein sollten.

Seite 38 *Master R und Sang, I*
Als Dom hatte Madame Sang vor meiner Kamera keine Probleme,
als Sub aber zunächst schon, weil sie sich da für zu verletzlich hielt.
Es dauerte ein Jahr, ehe sie sich dazu durchrang, dass ich zurück-
kommen und diese Bilder machen konnte.

Seite 39 *Sklave, ausgepumpt*
Am Ende der Szene sank Sang aufs Bett zurück und seufzte: »Oh,
der Sklave ist total ausgepumpt.«

Seite 40 *Play Piercing, I*
Ivan und Anne haben einen geistigen Draht zueinander, der mir
fast unheimlich ist. Beide sind fast 1,90 groß, und als ich darum bat,
sie fotografieren zu dürfen, stellten sie sich wortlos rechts und links
neben mich und küssten sich über meinem Kopf.

Seite 41 *Play Piercing, IV*
Anne wartete bis zur Mitte des achten Schwangerschaftsmonats, um
diese Fotosession zu machen. Sie hatte Rücksprache mit dem Arzt

page 43 *Tam and Kit*
I often thought that Tam was very motherly and protective in her relationship to Kit. When he put his head down on her breast after their scene, it seemed like a visual confirmation. A couple of years after this shoot, Tam began the process of gender reassignment and is now know as Alex.

page 45 *Bathroom Kiss*
After an elaborate hot wax and enema scene, Maria went into the bathroom to expel. Tanya followed her, and on a whim so did I.

page 46 *Rusty's Dream*
When we talked about the photo shoot, Rusty asked me to do this shot of her partner, Laura. She wanted a record of Laura's ethereal beauty. Our friend Lolita Wolf lay on the floor with a couple of fans creating the breeze.

page 47 *Laura's Dream*
Rusty peeks into the corner of the frame here, deep in top space as she canes Laura.

page 49 *Antonia in Heaven*
I loved the way Velvet's expression was in perfect synch with what Antonia (who was Thrash in earlier photos) might have been feeling. The little implements in her hands are chopsticks. Antonia was always the perfectly demure lady. They met at a commitment ceremony where Antonia was one of the bridesmaids. Their attraction was instantaneous, and they've been together ever since.

page 50 *Jack and Lolita, I*
She often practiced her whip technique while Jack was tied up. He did not like to be whipped, and she never touched him with it, but the sounds of the whip cracks would permeate the dungeon while he enjoyed his bondage time.

page 51 *Jim Mitchell*
Jim is a poetically beautifully gay man, who is adored from afar by all of the straight women in the scene.

genommen, welche Arten des SM-Spiels für das Baby unschädlich waren. Während der Szene bedeutete sie Ivan, wohin er die Braunülen setzen sollte – die Stiche laufen kreisförmig um ihren Bauch und beide Brüste –, und dann, unerwartet, liebten sie sich.

Seite 42 *Nona und Mark*
Als Nona das Fisting lernen wollte, ging sie bei einem wohlbekannten schwulen Ledermann in die Lehre. Unter seiner Anleitung übte sie, bis sie sich sicher genug fühlte, es zu Hause allein zu tun.

Seite 43 *Tam und Kit*
Tam ist sehr mütterlich und fürsorglich in ihrer Beziehung zu Kit, dachte ich oft. Als er nach der Szene den Kopf an ihre Brust sinken ließ, wirkte das wie eine visuelle Bestätigung. Ein paar Jahre nach dieser Session nahm Tam ihre Geschlechtsumwandlung in Angriff und heißt jetzt Alex.

Seite 45 *Kuss auf dem Klo*
Nach einer komplizierten Heißwachs- und Klistierszene ging Maria zur Toilette, um sich zu entleeren. Tanya folgte ihr, und auf eine Eingebung hin tat ich es auch.

Seite 46 *Rustys Traum*
Als wir die Fotosession besprachen, bat mich Rusty, diese Aufnahme ihrer Partnerin Laura zu machen. Ich sollte Lauras ätherische Schönheit im Bild festhalten. Unsere Freundin Lolita Wolf lag auf der Erde und erzeugte mit ein paar Ventilatoren den Luftzug.

Seite 47 *Lauras Traum*
Rusty, ganz in der Top-Rolle, lugt hier, während sie Laura züchtigt, rechts oben ins Bild.

Seite 49 *Antonia im Himmel*
Ich liebte die Art, wie Velvets Mimik synchron genau das ausdrückte, was Antonia (auf früheren Fotos hieß sie Thrash) wahrscheinlich fühlte. Die kleinen Instrumente in ihren Händen sind Ess-Stäbchen. Antonia war stets die perfekt sittsame Lady. Kennengelernt haben sie sich auf einer trauungsähnlichen Zeremonie, auf der An-

page 52 *Brian and Jaz, I*
This was shot at Hellfire, which doubled as a gay leather club called Manhole during the rest of the week. Brian worked his way through graphic arts school by managing Manhole at night.

page 53 *Brian and Jaz, II*
I love the little hands sticking out, as if to say »please don't spank me any more«.

page 54 *Gary and wynn, I*
They have lived in a 24/7 master-slave relationship for many years and consider themselves married. wynn is never allowed to wear clothing in their home. He must always address Gary as Sir, and is not allowed to sit or sleep on the furniture.

page 55 *Gary and wynn, II*
wynn worked with an artist to design the angel wings and barbed wire tattoo. It took fifty hours of needle work to imprint the design on his body. It's one of the most amazing tattoos I've ever seen.

page 56 *Gary and wynn, III*
They warned me in advance that there would be almost no warm up in their scene. Gary began caning wynn almost immediately, alternating this with single tailed whipping.

page 57 *Gary and wynn, IV*
When Gary stopped for a few moments to change implements, wynn continued to scream and shake his chains, as if he couldn't release all the pent up stimulation.

page 59 *Keith and Stephanie, Blowing*
We shot this at Hellfire/Manhole in one of the tiny bunker rooms in back. I used a wide angle lens, so I was up very close to them. There was a tremendous surge of heat, and then the roar of the fire. Very powerful.

page 60 *Sir C*
She dips her fingers in alcohol and then lights them on fire. The al-

tonia eine der Brautjungfern war. Von der ersten Sekunde fühlten sie sich zueinander hingezogen und sind seither zusammen.

Seite 50 *Jack und Lolita, I*
Sie trainierte oft ihre Peitschentechnik, während Jack gefesselt war. Er mochte Whipping nicht, und sie berührte ihn kein einziges Mal, aber der Knall der Peitschenschläge erfüllte das Verlies, während er sein Bondage genoss.

Seite 51 *Jim Mitchell*
Jim ist ein Schwuler von poetischer Schönheit, den alle Hetero-Frauen der Szene von ferne anbeten.

Seite 52 *Brian und Jaz, I*
Aufgenommen im Hellfire Club, der an den übrigen Wochentagen zum schwulen Lederclub Manhole mutierte. Durch seine nächtliche Arbeit als Clubleiter des Manhole finanzierte Brian sein Grafikstudium an der Kunstschule.

Seite 53 *Brian und Jaz, II*
Ich liebe die kleinen Hände, die sich abwehrend strecken, als wollten sie sagen: »Bitte, bitte, nicht mehr schlagen.«

Seite 54 *Gary und wynn, I*
Seit vielen Jahren leben sie in einer 24/7-Beziehung und betrachten sich als verheiratet. Im Haus darf wynn niemals Kleidung tragen. Er muss Gary stets mit »Sir« anreden und darf nie auf Möbelstücken sitzen oder schlafen.

Seite 55 *Gary und wynn, II*
Das Engelsflügel- und Stacheldraht-Tattoo hat wynn mit einem Künstler zusammen entworfen. Rund fünfzig Stunden waren nötig, um den Entwurf auf seinen Körper zu übertragen. Es ist eines der erstaunlichsten Tattoos, die ich je gesehen habe.

Seite 56 *Gary und wynn, III*
Man hatte mich gewarnt, dass die beiden ohne Aufwärmen sofort zur Sache gehen. Fast ohne Vorrede begann Gary mit dem Caning;

97

cohol on the surface of the skin burns off very quickly, and done properly there is no risk of burning the skin.

page 61 *Sir C and Thrash*
She swabbed alcohol on different parts of his body and then ran her burning fingers over the area. I used a long exposure to capture the quickly fleeting flames.

page 62 *Fireplayers, II*
Keith lit the floor on fire and he and Stephanie danced among the flames. When I shot this, I was thinking about how wonderful to be as young and free as these two. They have created their own Bindlestiff Family Circus, and travel around the country performing.

page 64 *Don and Susie Q, I*
When Don fell in love with Susie Q, he took her initial and became Don Q. They hired me to photograph their wedding – not the scene wedding, but the vanilla wedding with their families. I was honored by that, and have always thought of them as the Q family.

page 65 *Don and Susie Q, III*
Susie covered Don's body in various types of clips and clothespins, and then slowly removed them. He slumped down, spent, very deep in sub space. After the clips, she carefully laid him out on a gyn table and fisted him. It's one of his favorite things, and he taught her how to do it for him.

page 66 *The Long Shave*
Pete usually keeps his body shaved, but in preparation for this photo shoot, he let it grow in for about four months. It took about 3 hours for him to shave every hair off of his body, and I photographed the entire process.
His lover Tammey decorated the bathroom with Christmas lights for the photo shoot and spent the day with us also.

page 67 *The Fabulous Pet*
Pete morphed into Pet. One of the interesting things about Pet is that she makes no attempt at being female. She just loves to dress in

abwechselnd mit dem Rohrstock kam eine einschwänzige Peitsche zum Einsatz.

Seite 57 *Gary und wynn, IV*
Wenn Gary ein paar Sekunden innehielt, um das Werkzeug zu wechseln, schrie wynn weiter und rüttelte an seinen Ketten, als könne er all die aufgestaute Stimulation nicht loswerden.

Seite 59 *Keith und Stephanie, feuerspeiend*
Wir fotografierten dies im Hellfire/Manhole in einem der kleinen rückwärtigen Kohlenkeller. Ich benutzte ein Weitwinkelobjektiv, war den beiden also ganz nahe. Es gab eine explosive Hitzewelle, dann das Fauchen der Flamme. Sehr stark.

Seite 60 *Sir C*
Sie taucht ihre Finger in Alkohol und zündet sie dann an. Der Alkohol auf der Hautoberfläche brennt sehr rasch ab; bei fachgerechter Durchführung besteht keine Gefahr von Hautverbrennungen.

Seite 61 *Sir C und Thrash*
Sie tupfte Alkohol auf verschiedene Partien seines Körpers und strich dann mit ihren brennenden Fingern darüber. Mit langer Belichtung fing ich die rasch aufblitzenden und verlöschenden Flammen ein.

Seite 62 *Feuerspieler, II*
Keith machte Feuer auf dem Fußboden und tanzte mit Stephanie durch die Flammen. Beim Fotografieren ging mir durch den Kopf, wie herrlich es sein muss, so jung und frei zu sein wie die beiden. Sie haben später den Bindlestiff Family Circus gegründet und touren damit durchs Land.

Seite 64 *Don und Susie Q, I*
Als Don sich in Susie Q verliebte, übernahm er ihr Initial und wurde Don Q. Sie engagierten mich, um ihre Hochzeit zu fotografieren – keine Szene-Trauung, sondern die gutbürgerliche Hochzeit mit ihren Familien. Ich fühlte mich dadurch sehr geehrt und denke an sie stets als die Familie Q.

sexy outfits and wear lots of makeup. She is also a wonderful artist, who is her own model.

page 69 *Master Fred's Last Stand*
At the time of this shoot, Fred was preparing to go to Canada for gender reassignment surgery. He had lived as a woman for over a year, and wanted to complete the transition. This photo shoot was one of the very few times during that year that Fred had dressed as a man and it was a way of his saying goodbye to that part of himself.

page 70 *Pony Training, I*
Monica had bought a new pony outfit, and asked Master Fred to help her learn how to do all the various pony steps.

page 71 *Pony Training, II*
She wasn't the quickest student, but Master Fred tried his best to put her through her paces.

page 72 *Signal Whip, I*
In the end, Monica just kept on making silly mistakes and had to be punished, which she had hoped for all along!

page 73 *April and Monica at the Hotel 17, I*
This shoot was actually done in the year before Fred became April, while he was living full time as a woman. The female pronoun was extremely important to April, and if anyone slipped and called her »he« it would send her into a terrible depression.

page 74 *April and Monica at the Hotel 17, II*
April is a black belt karate expert, and made the difficult transition at her sensei from man to woman. But she never really passed as a woman, and people always stared at her in the most insulting ways. In the years that I knew her, she found the simplest thing like riding a subway terrifying.

page 75 *April and Monica at the Hotel 17, III*
April defined herself as a lesbian and always wanted to be with a biological woman. The fact that Monica was a cross dresser bothered

Seite 65 *Don und Susie Q, III*
Susie spickte Dons Körper mit mehreren Arten von Clips und Wäscheklammern und nahm sie dann langsam ab. Er sackte zusammen, erschöpft, tief in der Sub-Rolle. Nach den Clips legte sie ihn behutsam auf einen Gynäkologenstuhl und machte ihm ein Fisting. Das gehört zu den Dingen, die er am liebsten hat, und er hat ihr beigebracht, es für ihn zu tun.

Seite 66 *Die lange Rasur*
Normalerweise ist Pete am Körper glattrasiert, für diese Session jedoch ließ er sich vier Monate die Haare wachsen. Drei Stunden brauchte er, um sich dann jedes Haar vom Körper abzurasieren, und ich fotografierte die gesamte Prozedur.
Sein Lover Tammey dekorierte das Badezimmer für die Fotosession mit Christbaumbeleuchtung und leistete uns den ganzen Tag Gesellschaft.

Seite 67 *Die fabelhafte Pet*
Pete, mutiert zu Pet. Eines der interessanten Dinge an Pet ist, dass sie sich keine Mühe gibt, fraulich zu sein. Sie zieht nur gerne sexy Outfits an und legt viel Make-up auf. Sie ist auch eine begabte Künstlerin und ist ihr eigenes Modell.

Seite 69 *Master Freds letztes Gefecht*
Zur Zeit dieser Fotositzung bereitete sich Fred darauf vor, zur Geschlechtsumwandlungs-Operation nach Kanada zu gehen. Mehr als ein Jahr hatte er als Frau gelebt und wollte die Verwandlung nun abschließen. Unsere Sitzung war eine der ganz wenigen Gelegenheiten in diesem Jahr, da Fred noch einmal als Mann gekleidet auftrat; eine Art Abschiedsgruß an sein altes Ich.

Seite 70 *Ponytraining, I*
Monica hatte eine neue Ponyausrüstung erstanden und bat Master Fred, ihr die verschiedenen Gangarten des Ponys beizubringen.

Seite 71 *Ponytraining, II*
Sie war nicht die gelehrigste Schülerin, aber Master Fred tat sein Bestes, ihr auf die Sprünge zu helfen.

her. She eventually met and fell in love with the woman of her dreams. The last time I heard from her, they were living a quiet life together in rural Pennsylvania.

page 77 *Zoe*
I only shot two frames of this because I felt that the real picture would be the interaction between the two. But when I saw it later I realized that this image perfectly caught the essence of where Zoe wanted Flagg to take her. Here she is the perfectly objectified service slave, awaiting her master.

page 78 *Flagg and Tink*
This was the prelude to a shoeshine, which we shot at Hellfire. Flagg is a trainer at The Estate, a training facility for service-oriented submissives. Tink was one of his first trainees.

page 79 *Tink and the Club Rules*
Flagg would often bind Tink's breasts like this, and then attach little bells with hypodermic needles. She would walk around Hellfire on a Saturday night with the bells tinkling wherever she went.

page 80 *Rob and Lisa*
They are both artists who have been married for many years, and often use each other in their work. Their collaborations are wonderful. For this one, he wrapped her body in Saran wrap, molding it carefully to her shape. Then he gently cut it away and draped it on a hanger. It looked like an eerily discarded cocoon.

page 81 *Leonard and Michele, I*
Leonard and Michele were one of the first couples to welcome me to their home, and I often called them with my questions about the various SM activities. Leonard was a highly regarded activist in the community. He died suddenly of a heart attack in June, 1998. I miss him still.

page 82 *Angelbaby and G. A.*
For most people in the scene, my past as a porn photographer was a problem, and I had to convince them that my intentions weren't

Seite 72 *Einpeitscher, I*
Am Ende machte Monica doch immer wieder dumme Fehler und musste bestraft werden – genau das, was sie von Anfang an erhofft hatte!

Seite 73 *April und Monica im Hotel 17, I*
Die Sitzung fand in dem Jahr statt, in dem Fred noch nicht zu April geworden war, aber schon voll als Frau lebte. Das weibliche Pronomen war April äußerst wichtig, und verplapperte sich jemand und sprach sie mit »er« an, verfiel sie in schwere Depressionen.

Seite 74 *April und Monica im Hotel 17, II*
April ist Karatemeisterin (Schwarzer Gürtel) und durchlief den schwierigen Übergang Mann-Frau gerade zu der Zeit, da sie Sensei wurde. Sie ging jedoch später nie so ganz als Frau durch, und man starrte sie überall auf das beleidigendste an. In diesen Jahren hatte sie vor den einfachsten Dingen wie U-Bahn-Fahren große Angst.

Seite 75 *April und Monica im Hotel 17, III*
April definierte sich als Lesbierin und wollte immer mit einer biologischen Frau zusammensein. Dass Monica Transvestit war, störte sie. Am Ende lernte sie dann doch noch die Frau ihrer Träume kennen und verliebte sich in sie. Als ich das letzte Mal von ihr hörte, führten die beiden in Pennsylvania ein ruhiges Leben auf dem Land.

Seite 77 *Zoe*
Von diesem Motiv machte ich nur zwei Bilder, weil ich glaubte, die Interaktion zwischen den beiden sei fotografisch interessanter. Bei späterer Betrachtung erkannte ich aber, dass dieses Bild das ganze Wesen der Situation wiedergab, in die Zoe sich durch Flagg hineinversetzen lassen wollte. Hier verkörpert sie die perfekte dienstbare Sklavin, ihren Herrn erwartend.

Seite 78 *Flagg und Tink*
Dies war das Vorspiel zu einem Shoeshine, das wir im Hellfire aufnahmen. Flagg ist Trainer in »The Estate«, einer Ausbildungsstätte für auf Dienen eingestellte Subs. Tink gehörte zu den ersten Schülern.

sleazy. But Angelbaby and G. A. thought it was great, and even asked me how to get into the business.

page 83 *Bob and Ann*
We went to Bob's special place deep in the woods for this shoot. It's a place where he often went to meditate and be at peace before he met Ann. I love the way that he's wincing as she laughs.

page 85 *Vixen*
It seemed only appropriate that a voyeur would eventually run into a flasher. We were there for her to flash an Amtrak train, and her master, Big Al, is waiting on the track to cue us when it's coming. But in the meantime she flashed me, and that was the picture I liked best.

page 87 *Horse Farm*
Pony play is a very popular activity in the scene. Paul Reed, riding Piper Pony here, publishes a magazine called *Equus Eroticus* for the pony crowd. A lot of the big SM events have pony contests where they compete in various categories.

page 88 *Piper and MacKenzie, I*
Piper won Best-of-Show at the annual Leather Retreat event so often that they finally had to exclude her from competing. She can whinny just like a horse, and makes all the little nervous movements that ponies make.

page 89 *Piper and MacKenzie, II*
They were married just a few months after this day in the country.

page 91 *Happily Ever After*
Piper was walking along pulling the sulky at an easy pace, but I panned with a slow shutter speed to give the feeling of great speed. Lochai and MacKenzie seemed so carefree and gay – like a summer afternoon in some faraway other world. Watching them, I thought they might all ride off into the sunset and live happily ever after.

Seite 79 *Tink und die Clubregeln*
Flagg band Tinks Brüste oft so ab wie hier und brachte mit Braunülen kleine Glöckchen an. An Samstagabenden promenierte sie durchs Hellfire, und die Glöckchen klingelten, wo sie ging und stand.

Seite 80 *Rob und Lisa*
Sie sind beide Künstler, seit langen Jahren verheiratet. Häufig thematisieren sie sich gegenseitig in ihrem Werk. Ihre Gemeinschaftsarbeiten sind wunderbar. Für diese wickelte er ihren Körper in Transparentfolie und modellierte die Folie sorgfältig ihren Konturen entsprechend. Dann schnitt er die Hülle behutsam ab und hing sie auf einen Kleiderbügel. Sie wirkte wie ein gespenstischer Kokon.

Seite 81 *Leonard und Michele, I*
Sie waren eines der ersten Paare, die mich in ihrer Privatwohnung willkommen hießen, und ich stellte den beiden telefonisch oft Fragen zu den verschiedensten SM-Aktivitäten. Leonard war ein angesehener Aktivist der Szene. Im Juni 1998 starb er plötzlich an einem Herzanfall. Er fehlt mir noch heute.

Seite 82 *Angelbaby und G. A.*
Die meisten Szeneleute hatten mit meiner Vergangenheit als Porno-Fotografin ein Problem; ich musste sie überzeugen, dass ich keine unsauberen Absichten hegte. Angelbaby und G. A. fanden es klasse und baten mich sogar um Auskunft, wie man in die Branche einsteigt.

Seite 83 *Bob und Ann*
Diese Session veranstalteten wir an Bobs Lieblingsort tief im Wald. Früher, ehe er Ann kennenlernte, ist er oft hierher gefahren, um zu meditieren und seinen Frieden zu suchen. Es gefällt mir, wie er zusammenzuckt, wenn sie lacht.

Seite 85 *Sexy Füchsin*
Nur recht und billig, dass einem Voyeur irgendwann ein Blitzer über den Weg läuft. Wir waren hier, weil Lil einen Amtrak-Zug blitzen wollte, und ihr Meister, Big Al, wartete am Gleis, um uns zu signalisieren, wann der Zug kam. Inzwischen blitzte sie aber schon mal mich. Das Bild gefiel mir dann von allen am besten.

Seite 87 *Reiterhof*

Das Ponyspiel ist in der Szene sehr beliebt. Paul Reed, der hier Piper Pony reitet, gibt für die Ponyfans das Fachblatt *Equus Eroticus* heraus. Viele große SM-Events bieten Pony-Wettbewerbe, auf denen die Fans in verschiedenen Disziplinen gegeneinander antreten.

Seite 88 *Piper und MacKenzie, I*

Auf dem alljährlichen Leather Retreat Event räumte Piper so oft den ersten Preis ab, dass man sie schließlich von der Teilnahme ausschließen musste. Sie kann wiehern wie ein Pferd und macht all die kleinen nervösen Bewegungen, die Ponys machen.

Seite 89 *Piper und MacKenzie, II*

Wenige Monate nach diesem Tag auf dem Land heirateten sie.

Seite 91 *Happily Ever After*

Piper zog das Sulky in lockerer gemächlicher Gangart, aber ich machte mit langer Belichtung einen Schwenk, um Tempo vorzutäuschen. Lochai und MacKenzie wirkten so sorglos und beschwingt – ein Sommernachmittagsidyll wie aus einer fernen anderen Welt. Ich dachte: Jetzt fahren sie vielleicht weiter bis in den Sonnenuntergang; ein Ende wie im Märchen.

This book could have never happened without the generosity of / Dieses Buch wäre niemals entstanden ohne die großzügige Unterstützung von:

Alex Cao, Chris Messick, Erich Moan, Michael Lutin, Allen Frame, Michael Rosen, A.D. Coleman, Klaus Kehrer, Birgitt Kehrer, Alexa Becker, Christina Dinkel, Vanessa Buffy, Frank Schelling, Ariane Mensger, Dieter Kuhaupt, Christoph Vogl, Sabine Stevenson, Barbara Bell, Lady Amanda Blair, Georges Nahitchevansky, Joseph Bean, Charles Moser, Lisa Vandever, Marianne B., Angie Reed Garner, Margo Eve, Thomers, Slow Tiger, Rick Savage, Allyn R. Greenfield, Morgan Lewis HMQ, Leonard Waller, David »Dee« Johnson, Brian Herzig, Michele Buchanan, Pet Silvia and Tammey Stubbs, Art@Large, Grady Turner, Museum of Sex, John Strausbaugh, Velma J. Bowen, Mark Richards, Elissa Wald, David Gray, Susan Wright and Kelly Beaton, Bob Berkowitz, Jayme Waxman, Terry Williams, Carrie, Leda Resurreccion, Bruce, Thom Adams, Radiant Light Gallery, Yvonne DeSoto and Anthony J. Inciarrano, Brian Clamp, Clampart, Zoe, Beth Kwon, Tim Haft, Hilton Flax, Lolita Wolf, Jack McGeorge, John Wirenius, Jeffrey Douglas, Mary Catelynn Cunningham, Jim and Goldie, Colette Connor, Bob Vizzini, The Camera Club of New York, Mariette Pathy Allen, Master Jim, Madame Sang and Master R., Alison Maddex, Amy Rosemarin, Carl, Jean, Neville Chambers, Elise Antonelli, School of Visual Arts, Christopher Klopotowski, Cassandra, Glenda Rider and Sarah Humble, Matty and Lisa Marie Jankowski, Bernadette, Nancy Pindrus, Ivan and Ann, Mistress Nona, Mark, Barbara Ann Levy, Richard Anderson, Ed Moore and Stephen Decker, Mark Alan Stiffler, Abby and Robert, Alex and Kit, Bleu, Anastasia, Efrain Gonzalez, Michele Serchuk, Rusty and Laura, Jim Mitchell, Greg, Frazier Botsford, Lori Dwinelle, Jaz, Gary and wynn, Keith Nelson and Stephanie Monseu, John Santerineross, Guy Trebay, Soulhuntre and Kimiko, Sir C, Flagg and Tink, Terri Clark, Linda Slodki, Yoni Susan Fischer, Bob Hancock and Austin Sanderson, Susie Q. Degnan, Don D., Jurgen Boezt, David Bowman, Rachel Kramer Bussel, Master Fred, April, Monica, Rob and Lisa, Claudia LaRocco, Dean Schabner, Angelbaby and G.A., Bob, Anne Justi, Vixen, Veronica Vera, Candida Royalle, David Steinberg, Mark I. Chester, Big Al, Charles Gatewood, Paul Reed, Piper Pony and MacKenzie, Lochai, Lee Musselman, Ross Bennett Lewis, Andy Antipas, The Eulenspiegel Society, Black Rose, Lesbian Sex Mafia, Gay Male S/M Activists, St. Louis Leather & Lace, Pantheon of Leather, SigMa, Leather Archives & Museum, Satyricon, and my family/und meiner Familie – Gary and Andrea, Janie and Veikko, Mara, Halston, Leslie, and my wonderful Mom/ und meiner wundervollen Mom.

© 2003

Kehrer Verlag, Barbara Nitke, A. D. Coleman

Texts by / Texte von: A. D. Coleman, Barbara Nitke

Translation / Übersetzung: Dieter Kuhaupt

Proofreading / Verlagslektorat: Ariane Mensger

Design and Production / Gestaltung und Herstellung:
Kehrer Design Heidelberg (KK / Christina Dinkel)

Bibliographic information published
by Die Deutsche Bibliothek
Die Deutsche Bibliothek lists this publication
in the Deutsche Nationalbibliografie;
detailed bibliographic data is available
in the Internet at http://dnb.ddb.de.

Bibliografische Information Der Deutschen Bibliothek
Die Deutsche Bibliothek verzeichnet diese
Publikation in der Deutschen Nationalbibliografie;
detaillierte bibliografische Daten sind im
Internet über http://dnb.ddb.de abrufbar.

Printed in Germany

Kehrer Verlag Heidelberg ISBN 3-933 257-94-8